Making Faces

# MAKING FACES
## drawing expressions for comics and cartoons

8fish

**IMPACT**
CINCINNATI, OHIO
www.impact-books.com

**8FISH** is a jack-of-all-trades creative work-shop that has been producing mind-blowing animation, design and illustration for over ten years. The secret to 8fish's success is a feisty team of incredibly talented and versatile artists who constantly challenge themselves and each other. Their combined artistic knowledge is enough to fill volumes, but currently they are working on unloading it one book at a time.

**Making Faces: Drawing Expressions for Comics and Cartoons**. Copyright © 2008 by 8fish. Manufactured in the United States of America. All rights reserved. No part of this book may be reproduced in any form or by any electronic or mechanical means including information storage and retrieval systems without permission in writing from the publisher, except by a reviewer who may quote brief passages in a review. Published by IMPACT Books, an imprint of F+W Media, Inc., 4700 East Galbraith Road, Cincinnati, Ohio, 45236. (800) 289-0963. First Edition.

**fw media**

Other fine IMPACT Books are available from your local bookstore, art supply store or online supplier. Visit our website at www.fwmedia.com.

14  13  12     6  5  4

DISTRIBUTED IN CANADA BY FRASER DIRECT
100 Armstrong Avenue
Georgetown, ON, Canada L7G 5S4
Tel: (905) 877-4411

DISTRIBUTED IN THE U.K. AND EUROPE BY DAVID & CHARLES
Brunel House, Newton Abbot, Devon, TQ12 4PU, England
Tel: (+44) 1626 323200, Fax: (+44) 1626 323319
Email: postmaster@davidandcharles.co.uk

DISTRIBUTED IN AUSTRALIA BY CAPRICORN LINK
P.O. Box 704, S. Windsor NSW, 2756 Australia
Tel: (02) 4577-3555

**Library of Congress Cataloging in Publication Data**
8fish.
  Making faces : drawing expressions for comics and cartoons / 8fish.
     p. cm.
  Includes index.
  ISBN 978-1-60061-049-3 (pbk. : alk. paper)
1. Facial expression in art. 2. Drawing--Technique. 3. Comic books, strips, etc.--Technique.  I. Title.
  NC770.A15 2008
  741.5'1—dc22          2008000755

Edited by Jeffrey Blocksidge
Designed by Wendy Dunning
Production coordinated by Matt Wagner

## METRIC CONVERSION CHART

| TO CONVERT | TO | MULTIPLY BY |
|---|---|---|
| Inches | Centimeters | 2.54 |
| Centimeters | Inches | 0.4 |
| Feet | Centimeters | 30.5 |
| Centimeters | Feet | 0.03 |
| Yards | Meters | 0.9 |
| Meters | Yards | 1.1 |

N. GIBBS RATNOCK

## Acknowledgments

We'd like to acknowledge the whole gang at 8fish. It was an awesome experience to work on this together, and everyone's individual contributions, really made this book special. Big thanks to Pam Wissman for letting us in on the fun, and Jeffrey Blocksidge for helping us conceptualize and complete this project. Lastly, thanks to all the aspiring artists who will surely buy multiple copies of this book for years to come.

## Dedication

**BEN**—To Jess and Lilly, the loves of my life.

**BRANDON**—To Mom, for always keeping the desk drawer stocked with paper.

**BRONZE**—To my dad, Roland Swallow. He's the reason I draw for a living. He was passionate about art and took a creative approach in all things. An average father may have dissuaded me from making a career in art, but not my dad. I love him.

**GIBBS**—To my dad, who taught me to love art, and to my college professors, who took all the fun out of it by giving me a more critical eye.

**BLAKE**—To Mom and Dad, for all the encouragement.

**ERNIE**—To my wife, Wendy, and our girls.

# TABLE OF CONTENTS

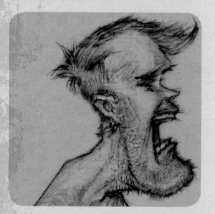

# The Power

It's no big surprise that art and expression are commonly considered synonymous. In some art movements this may not be the case, but once we enter the world of comics, its unarguable. Comics began as a "pulp" medium: their primary purpose was to grab the reader's attention with sensationalism and larger-than-life drama. Comics have since expanded into broader areas of sophistication and subtlety, but they still are all about expression. All comics have characters, and all characters have expressions.

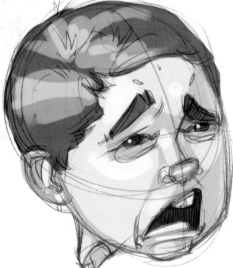

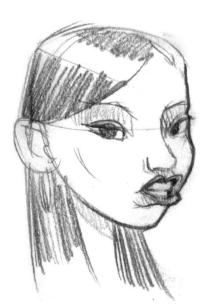

# of Expression

Chances are, you already know how to draw some expressions. You can draw someone that looks happy, sad or angry. But you can get only so far with happy, sad and angry. If you truly want to create characters that are realistic, three-dimensional and engaging, you have to start delving into the infinite number of varied and complex expressions beyond happy, sad and angry. Why? Because the human experience (even for superheroes) is way more interesting.

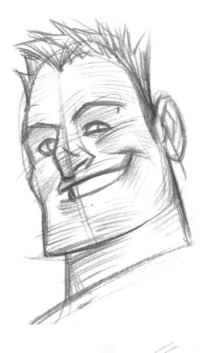

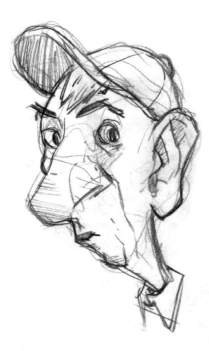

# The 4 Points of Expressions

**EXPRESSIONS SHOW:**

**1. State of Mind**   What we would commonly call feelings. But state of mind also means thoughts, and thoughts about what you're feeling and feelings about what you're feeling. (Complicated, we know.)

**2. Personality**   This is an extension of state of mind, but more fundamental. Who your character is should show on their face.

**3. Relationships**   Expressions are essential to showing how two people feel and think about each other. For example, when a man and a woman exchange flirting glances, we know exactly what their relationship is.

**4. Involuntary Physical States**   Bad gas, sickness, pain, relief. Sometimes the body feels something so intensely and so rapidly that it shows up on the face before we can even do anything about it.

## EXPRESSIONS ARE STORIES

Now, try to think of some sort of story that isn't going to make use of expression in one of the four ways we've outlined. You can't—and you know why? Stories are all about how people react to their own state of mind, to each other, and to the world around them. And the expressions of your characters are the best tools you have to communicate those reactions.

# Creating Expression

Here are a few guidelines to keep in mind as you create expressions:

- Find the reason behind the expression.

- Expressions are always reactions, so be specific and clear about what your characters are responding to.

- Be specific about the expression.

- Happy, sad and angry are usually too general. What is unique about your character's particular emotion in this moment? How is it different from another type of emotion in another moment?

- Observe expressions from real life.

- Watch the expressions of your friends and family. Try to identify expressions that you don't have a name for, and learn how to draw those expressions.

- Draw with feeling.

- Remember those class pictures you took as a kid, when you were told to smile and you stretched open your mouth in a big fake grin? The picture ended up looking more like you were being electrocuted, or like you had diarrhea, didn't it? That's what the expressions you draw will look like if you don't draw with feeling. Draw with the same passion you want your characters to have, and their expressions will explode off the page.

## ABOUT THIS BOOK

Our goal is to bring you to a point where you can create expressions that move you and your audience: expressions that are powerful, realistic and unique.

By studying and applying the principles presented here, you will learn to create expressions that are impossible to describe with words, but that communicate exactly how your character is feeling. In other words, you should be able to create characters that act like real people.

To do this, you will follow the process that all artists follow: Start with the general and move to the specific. Start by learning the big shapes and the general expressions, then move on to the little details and the idiosyncrasies that make an expression fun.

Take time as you go through the book to understand the principles and fundamentals.

Don't be afraid to make mistakes, don't give up, and have fun.

### Now let's get started!

# The Artists of 8fish

I received a head start in illustration at the age of twelve when my mom made good on her threat of throwing out the TV. While the TV took a two-year sabbatical in the garage, I polished my drawing skills. I have been a professional illustrator since high school and haven't worked a day since. The only things I love more than 8fish, which I established in 1995, are my wife and three daughters.

**Ernest Harker**

I've always hated coloring books. My mother reports that when we were children, she would buy my brothers and I coloring books and we would proceed to draw in the empty spaces. Coloring in someone else's drawing is fine, but the passive filling of white spaces between black lines can't compare to the magic of inventing your own worlds, creatures, machines and characters. If you can learn to draw, you can create universes as wide as your imagination.

I still avoid coloring books, and take every chance I can to fill up empty pages. The experience gets better the more I learn about drawing and challenge myself. Those rare moments when I'm amazed by my own work make all of the study and patience worth it, and push me to keep improving.

I hope I can share the little bit of what I've been happy to learn in this process.

I was born into a long line of designers and architects who were sadly disappointed when I showed them my first monster.

Over time, my abilities to disappoint became ever stronger with each new tool I acquired. With an arsenal of deadly artistic weapons under my belt (e.g., the computer, my Wacom tablet, acrylics, inks, etc.), I had the power to destroy!

Then I found out there were people who actually liked my work, and my evil plan of artistic disappointment began to crumble beneath me. So I took a job as an art director for 8fish, which is how I got this gig.

**Ben Simonsen**

**Brandon Dayton**

**Blake Loosli**

I think my artistic abilities originated from being bored when I was a child. If I had had cable television at home or engaging teachers at school, I wouldn't be contributing to this book. I started out drawing a lot of self-portraits. This helped to fuel my massive ego. Propelled by my ego, I kept drawing through middle school and high school. When I was thirteen, I saved up $180 and bought my first Wacom tablet. Since then, most of my work has been digital. I earned a bachelor of fine arts degree in illustration from Brigham Young University in 2005. Some of my favorite artists are J.C. Leyendecker, Sebastian Krüger, Roberto Parada and Enrique Fernández.

**Gibbs Rainock**

I was born in Mechanicsville, Virginia, in 1979. Because of my large forehead I was able to store many visuals within my cranium. I worked as a caricature artist for five years at Paramount Kings Dominion in Virginia. I attended Brigham Young University in Utah and graduated with a bachelors degree in animation. I am now writing this sentence for a book about expression.

**Bronze Swallow**

I WAS BORN,
I DREW,
I DIED.

# 1 The Fundamentals

As we talked about in the introduction, there are a lot of different reasons for expressions, but whatever the reason, it all ends up on the face. Which is why you've got to start with the so-called fundamentals. In this chapter we'll cover how to draw basic heads, mouths, noses and eyes. You'll learn about all their standard movements, and how they change shape when they move.

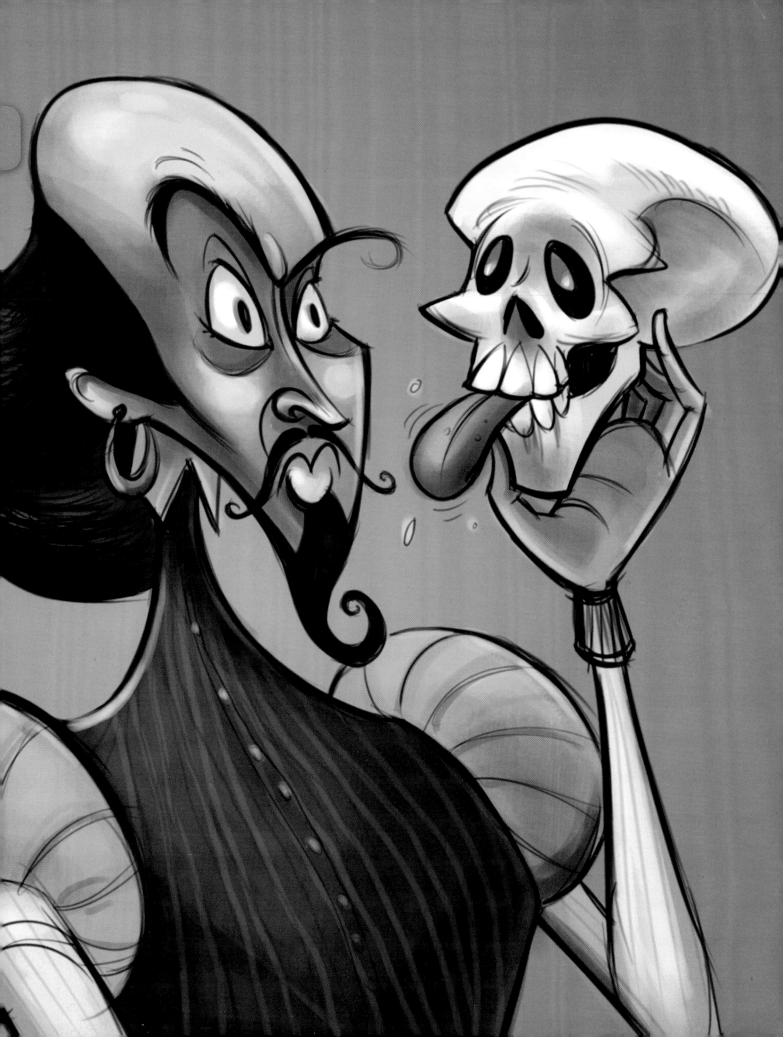

# Materials and Equipment

These pages show the materials and tools that we use for expressing our ideas visually. All artists are unique, so when it comes to tools, each of us prefers something different. But, every artist's arsenal includes such basics as paper and pencil.

## Paper

If you're anything like us you'll find that any paper will do—even yellow sticky notes work great for nailing down your ideas. However, a ream of cheap 8.5" × 11" (22cm × 28cm) copy paper purchased from your local grocery or office supply store will give you a little more room to work. Most of us prefer spiral-bound sketchbooks with nice, heavy paper and a medium tooth, like 30 to 60 lbs. (65gsm to 125gsm). Sketchbooks in a variety of sizes and weights can be bought at art supply stores for the same price or slightly more than a ream of good, thick paper.

## Pencils

This is where it gets personal. A good pencil is an artist's best friend, and when you find a brand that you like, the relationship may last for a lifetime. (Even so, many a drawing has been well rendered with a standard, chewed-up no. 2 pencil long after the eraser has been worn away.) Our list includes the following: Mechanical pencil—any weight is fine, but make sure you get soft lead (HB or B). Col-Erase pencil in Blue or Carmine Red—for blocking in your rough; these colors are easily removed on the computer or copy machine after your dark line has been drawn over the top. Faber-Castell Polychromos pencil—for your tight clean-up drawing. Remember, in the end it's really up to you and what you like.

## Pens and Markers

For some of us, using a standard black ballpoint pen for drawing and sketching is a lot of fun, considering that it forces us to be accurate because mistakes can't be erased. Others prefer to use them for the finishing touches because they make a nice black line. You may also consider using felt-tip pens like the Sakura Pigma Micron, which comes in a variety of sizes. The Pilot Precise Rolling Ball pen (extra fine) works great for inking in details and making sure they are black. A variety of pens and markers can be found at your local art supply store on racks with places to test each one before you buy. Once you've found a pen you like, pick up a few of them in case the ink runs out right in the middle of a big, life-or-death project.

## Mirror, Mirror

What does a mirror have to do with drawing? Well, nothing, really—except that a good facial expression is usually based on a good reference, and your handsome mug in a small mirror taped to your drawing table might provide all the reference you need. No longer will they only be used for cleaning the spinach out of your teeth.

### OVERCOMING DRAWING BIAS

We all have an unconscious bias toward our own drawings, so much so that we sometimes miss errors that are glaringly obvious to someone else. As you're drawing, hold your picture up to the mirror, and you'll see what we mean. The reverse image of your masterpiece will suddenly seem like a childish scribble. All the errors will become apparent and you'll be able to fix them in a snap. If you don't happen to have a mirror handy, turn your drawing over and hold it up to a light. Just make sure you don't have anything drawn on the other side.

## Pencil Sharpener

Any pencil sharpener will do, but a good electric one will give you a nice sharp tip. You can also get a battery-powered one for those drawing sessions on the road. If your budget calls for a hand-held version, try to get one that is all metal. Plastic body versions quickly lose the strength to hold the metal blades for sharpening.

## Software

If you can afford it, good software can really speed up the artistic process, especially in a professional working environment. Our software of choice includes Adobe Photoshop and Corel Painter. Each has the ability to mimic the look of all types of mediums, including pencil, pen, watercolor, acrylic, oil and so much more. But these programs are almost useless for an artist without a trusty pressure-sensitive graphics tablet made by Wacom. These tablets give you a feeling similar to drawing on paper. Once you get used to using one, you will quickly see the benefits. They come in a variety of sizes and price ranges.

# Drawing and Sketching

A good drawing will set you apart from the crowd of other would-be artists who claim they can wield a graphite pencil. It's all in how you lay down your marks. Following these tips will not only make your work look better, but will help you to work faster with less erasing.

**DRAW ALL THE TIME**

Drawing constantly will increase your confidence, and that confidence will show through in your drawings.

## Thick to Thin Strokes

Strokes with varying width add interest and weight to your drawings. Use the side of your pencil as well to get softer lines for blocking in shapes. Create shading from light to dark by gradually applying more pressure to the pencil.

## Be Confident

Confident strokes look much better (even if they're in the wrong place) than a series of tentative hatch marks.

Do

Don't

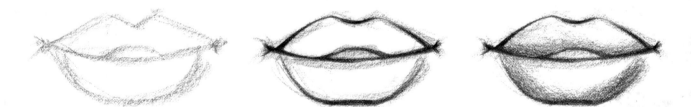

## Keep It Light At First

When blocking in your initial shapes, keep it light by using the pencil's edge instead of the point. When you feel like you have got it down, turn your pencil back up and use the tip to create edges, using thick and thin lines. Once the outline is complete, rotate the pencil back down to create the shading.

# Inking and Shading

When inking your drawings, keep in mind the line quality. Line quality refers to the attributes of your line work that emphasize form, weight, volume and focus. This can be the crucial element to really making your finished drawing pop.

### Tapering Adds Volume
Taper your strokes at the ends. Strokes that end abruptly kill the sense of volume in a drawing.

Lines should be even and smooth. Draw from your wrist and elbow to make continuous, smooth lines.

## TYPES OF MARKS FOR SHADING

### Thick to Thin
This is a standard mark for shading with ink. Start thick in the shadow areas and thin out toward the light areas.

### Crosshatching
Stroke in two directions to create transitions from dark to light.

### Airbrush Spatter
Use an airbrush filled with ink to get this shaded effect.

### Ink Spatter
Next time you want to add some texture or shading to your work, dip the tip of a toothbrush into your ink and use your thumb or pencil to run across the bristles. Be sure to aim it at your paper instead of at your friend.

### Bold and Subtle Strokes
Use bolder strokes for larger shapes and shapes in the foreground. Bolder strokes should also be used on the underside of shapes to give them a sense of weight.

Use subtler strokes for smaller shapes and shapes in the background. Smaller strokes should also be used to describe details on the surface of objects.

Strokes can change in thickness to emphasize the fullness of an object. For example, a stroke should be wider at the fullness of the curve of a cheek.

Once you've finished the inking, let it dry completely. Then you can come back with an eraser to remove your pencil lines.

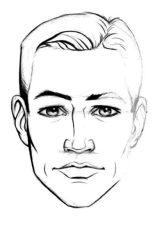 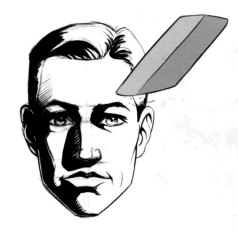

# The Head

Remember, always start with the big shapes first. When it comes to expression, that means learning how to draw the head. This lesson is the foundation of everything else you'll be doing in this book with expressions, so take the time to master it.

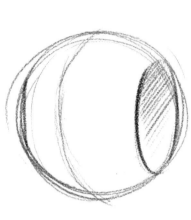

### The Cranium

The head is made up of two main parts: the cranium and the face. The cranium is a big sphere with the sides lopped off; it makes up the bulk of the head.

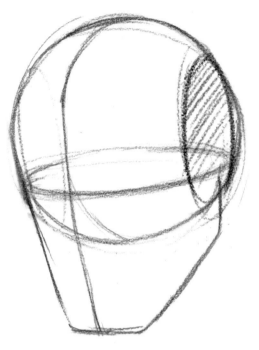

### The Face

The face is a tapered box, with a sloped bottom. It hangs off the cranium, from the eyes down to the chin and jaw.

### The Face and Cranium Together

You can think of the way they fit together as a bowling ball with a beard.

### Um ... Yeah

Remember that this just gives us the general shape of the head. Do not try to put the eyes and nose of your face where the bowling ball holes are!

20

# Demonstration

Let's draw a simple head from the front.

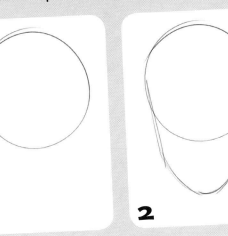

**1**

**2**

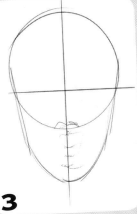

**3**

Too high!

**4**

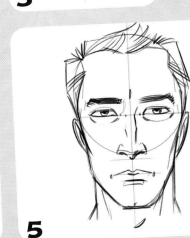

**5**

## 1 Draw a Circle
Start by drawing a circle. This is your cranium. Think of it as a round ball, not a flat circle.

## 2 Add the Face as a U-Shape
Next, add the face. You can do this by drawing a U-Shape to define the jaw.

## 3 Add Centerlines
Now, add your construction lines: one line splitting the head in half vertically and another splitting it in half horizontally. The horizontal line is called the *eye line*. The vertical line is called the *centerline*.

## 4 Add Eye, Nose and Mouth Lines
Make sure your eye line is in the middle of the head, not in the middle of the cranium. The middle of the cranium is up too high for the eyes.

Add another horizontal line halfway between the eye line and the bottom of the chin. This is where the bottom of the nose will sit. Make another line one-third of the way down from the nose to the chin. This is where the mouth will sit.

## 5 Add Features and Details
Finally, add the facial features. Place the eyes about one eye-width apart. Place the ears underneath the eye line.

## WRAPPING AROUND THE FORM

When we look at a face straight on, the construction lines form a simple cross. When we start moving the head around, the construction lines stay in the same place in relation to the features and thus help to establish direction and dimensionality as they move in relation to the picture plane.

As you draw a head turned to one side, imagine that you are wrapping extended construction lines like string around three-dimensional shapes. This technique is called "wrapping around the form."

# DIFFERENT VIEWS OF THE HEAD

Let's practice some simple head shapes from different points of view. Don't worry about the features for now; just focus on the cranium, face and construction lines.

## PROFILE VIEW

The profile view has an eye line, but no centerline. That's because the centerline here represents the edge of the face. The back of the jaw sits about halfway between the front and back of the head, and the ear sits right behind the jaw.

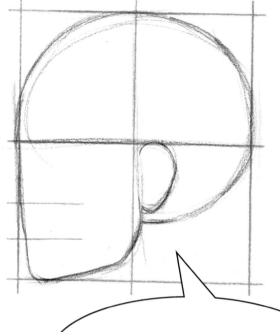

### Profile View

Construct the profile view within a box divided into four quadrants. The head is about as long as it is tall, and the jaw and ear fall right along the halfway line from front to back.

> The head doesn't sit right on top of the neck in profile. The neck actually extends out of the body at a 30° to 45° angle.

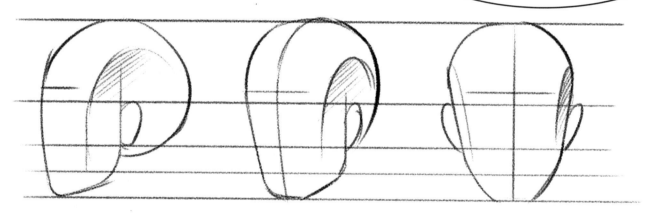

### Three-Quarters View

Notice that the height of the head and the eye line stay in the same place as we rotate the head. The only thing that moves is the centerline.

## KEEP PRACTICING!

Keep practicing drawing basic head shapes from different points of view (POV). We've looked at seven different angles, but there are a million different angles in between and beyond. Try to draw a head from a completely different POV, but if you get stuck, referring to a simpler POV can help.

## THREE-QUARTERS VIEW

This is where things get interesting. The three-quarters view is simply the face rotated halfway between the front view and the profile view. This view is called a three-quarters view because now you can see three-quarters of the face. It can be constructed by combining the front and proflie views.

## WORM'S-EYE AND BIRD'S-EYE VIEWS

You can use the technique on the previous page to figure out your worm's-eye and bird's-eye views. Start with a profile view, with the chin tilted up or down.

### THE SECRET WEAPON — THE NECK

The neck is not a part of the head or the face, but it can make a big difference with expression. A body standing upright and perfectly still can give you all the points of view of the head on this page, and the neck does it all.

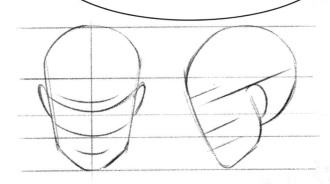

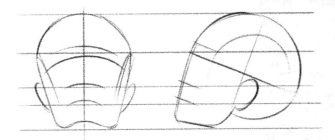

### Maintain the Centerline

As you tilt the head up and down, notice that the centerline stays in the same place, while the placement of the eye line, nose line and mouth line changes.

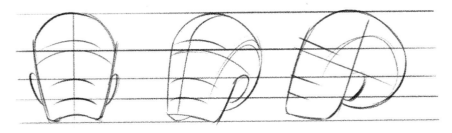

### Three-Quarters Worm's-Eye View

Remember to think of the head and features as three-dimensional, and always wrap your construction lines around the form. The head shape is very important. Once you master this, everything else will fall into place.

### Three-Quarters Bird's-Eye View

From here you can use this technique to create a three-quarters bird's-eye view. Notice how the eye line, nose line and mouth line curve as the head tilts up and down. They're wrapping around the form!

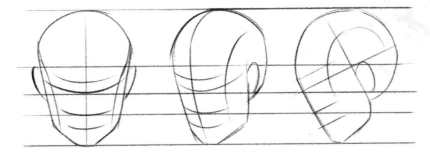

# Jaw and Mouth

## THE JAW

The jaw is the largest moving part of the face. It operates any time you open your mouth: talking, eating, yelling or whatever.

The jaw almost always works in conjunction with your mouth muscles, but also notice how it moves by itself and what it does to the face.

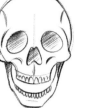
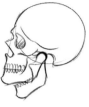

### The Jaw Swings

The jaw is hinged to the skull right in front of the ears, and swings back and down.

## THE MOUTH

The mouth is made up of the lips and a mass of seven interconnected muscles that sit under and around the lips. The illustrations show three basic mouth shapes and describe which muscle groups make them.

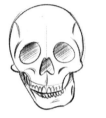
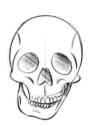

### ... and Slides

The jaw also has limited side-to-side as well as forward and backward movement.

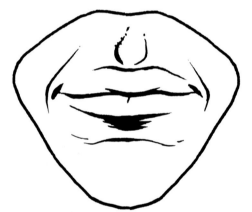

### The Mouth

Once you know the basic mechanics of the mouth's muscle groups and how they transform the face, you can create an infinite number of unique mouth shapes.

### The Frown Muscles

These muscles pull the sides of the lips down toward the side of the face, causing general frowning motions.

### A Big, Weird Frown

The muscles extend all the way down the neck onto the chest. When you do a big frown you'll feel your neck tighten up all the way down to your clavicle. That's a big frown!

### The Smile Muscle

This major muscle draws the corner of the lips up and away from the middle of the face.

A natural smile, with no other muscles engaged, will part the lips to show the top row of teeth.

# THE MOUTH FROM VARIOUS VIEWS

The key to drawing the mouth is to understand how it wraps around the form of the jaw. In a way, drawing the mouth is like adding a detail to an established surface, but it does have some independence.

### Bird's-Eye View

As you look at the mouth from a bird's-eye view, you see less of the top lip.

### Worm's-Eye View

As you look at the mouth from a worm's-eye view, you see more top lip. In both views, a relaxed mouth will curve as it wraps around the form.

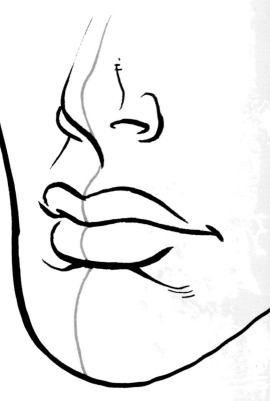

### Three-Quarters View

The mouth in three-quarters view doesn't just wrap around a cylinder. The lips sit on top of a mass of muscles so they stick out a little bit.

Indicate a centerline when you draw the mouth in a three-quarters view. It'll keep you aware of the contour of the mouth and lips.

### Profile View

When relaxed, the corners of the lips don't extend back very far; they stay in front of the eyes. Notice the slope from the nose to the chin. The bottom lip sits behind the top lip and the chin sits behind the bottom lip.

# THE LIPS

The lips are the most malleable and therefore one of the most expressive features on a face.

### Moving on Call

When the mouth is resting, the lips are like two modeling-clay snakes that have been pushed together so they kink in the middle. As the muscles of the face move and contort, the lips stretch and squash with them.

## Demonstration

## HOW TO DRAW LIPS: MR. BILL'S "THREE BEAN" METHOD*

Here's a simple method for drawing lips. At the very least it'll give you a basic understanding of their form. Once you understand the form, you can chuck the magic beans and draw lips on your own.

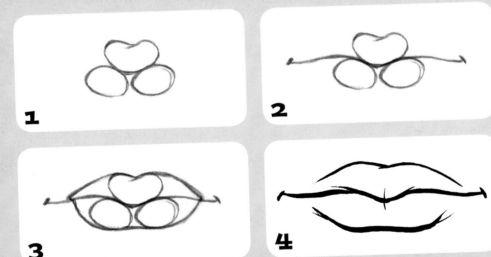

**1 Three Beans**
Draw three beans: a kidney bean sitting on top of two lima beans.

**2 Three Beans and a Line**
Draw the corners of the mouth out to the sides of the beans. Where you place these corners will determine how wide the mouth is. Run a line from one corner of the mouth between the beans and connect it to the other corner. This forms the space between the upper and lower lips.

**3 Three Beans and More Lines**
Start a line, a speck away from the corner of the mouth, and stretch it over the top of the kidney bean to the other side of the mouth. Continue the line around the bottom under the lima beans back to where you started.

**4 Beans Be Gone!**
Now, erase the beans and add any detail. Remember to darken the line between the lips. It's the opening to the mouth, so it should be much darker than the top and bottom of the lips.

*Thanks to Bill Larsen

# POUT, PUCKER AND SNEER

The movements of the lips are enabled by a variety of muscles. These muscles also contort the skin surrounding the lips as they contract or stretch.

## Pucker in Three-Quarters View

The pucker exaggerates the mouth mass that sticks out in three-quarters view. The dips and valleys on your centerline are more obvious and the corners of the lips move to the center.

## Pucker

The pouting muscles push the lips out, away from the face and up toward the nose.

## Wipe That Turkey Off Your Face!

The pout uses the same muscles, but they also tighten the lips together or push them back between the teeth.

## Glass Jaw

From a worm's-eye three-quarters view you can see how the pucker sticks out. This is the POV you'd use if you're drawing a guy getting upper-cutted in the face.

## Sneer

The sneering muscle raises the top lip in a sneer while pushing the nose up and flaring the nostrils.

## Sneer in Profile

Like the resting mouth, the sneer in profile doesn't go past the front of the eyes. The top lip comes forward a bit and the nose scrunches up and gets shorter.

# SMILE AND FROWN

Things get a bit more complicated with a smile from a worm's-eye view or a frown from a bird's-eye view. The motion of the expression goes against the curve of the face.

### Anatomy of a Smile

A smile from a bird's-eye view is exaggerated by the curve of the face. The lips flatten somewhat as they are pulled against the teeth.

### Views of a Frown

The cheeks scrunch down in the frown from a worm's-eye view. There aren't any big surprises as you look at a frown in profile. Kind of a bummer.

### Bird's-Eye Frown

With the bird's-eye frown, the downward slope of the lips becomes less obvious. You still see less of the top lip.

### Worm's-Eye Smile

The smile still follows the curve of the face but the bottom lip becomes more neutral and it is the corners of the mouth that indicate the smile.

## WORKING TOGETHER

Now, let's see how the mouth muscles work together with the jaw.

In general, you'll see more of the bottom row of teeth as the mouth opens up and the jaw swings back.

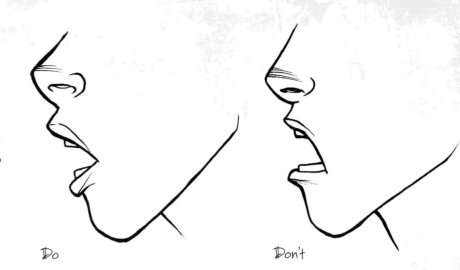

Do                    Don't

### Open Mouth in Profile

The most important thing to notice here is that the chin doesn't move straight down, it moves down and back as the jaw swings open.

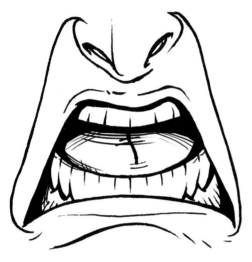

### Open-Mouth Frown With a Sneer

This gives you a standard comic book yell. The sneer pulls the top lip up while the frown pulls the bottom lip down, giving you maximum mouth exposure. You'll see a lot of teeth and a lot of throat.

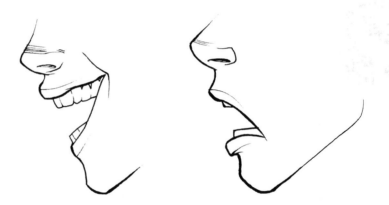

### Open-Mouth Smile and Frown in Profile

You can see the jaw's swinging motion pretty clearly in the open-mouth smile and open-mouth frown in profile.

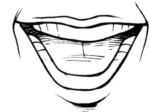

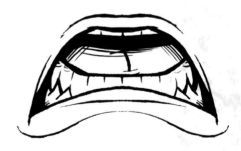

### DRAW A LONGER JAW

As you're drawing a head with an open mouth, make sure you draw the jaw longer. If you don't, you won't have enough room to place the mouth, and your face will look like a dummy puppet.

### Open-Mouth Smile

This is the "yay!" expression. Sometimes both rows of teeth are shown, but often just the top.

### Open-Mouth Frown

With an open-mouth frown you can see more of the bottom row of teeth.

# The Eye

It is important to remember that, like the head, the eye has form. It's a sphere lodged into a socket. It's also important to remember that the eyelids that cover the eye also have form. The whole thing is like an orange with a section of peel removed.

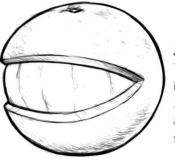

**An Orange?**
The outside form of an eyelid is as round as the eye inside. Just like an orange peel, an eyelid has an edge that shows its thickness.

## Demonstration

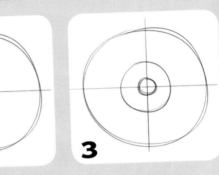

1

2

3

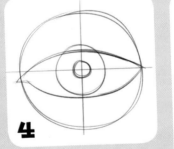

4

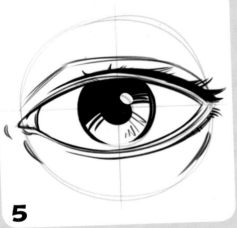

5

**1 Start With a Circle**
Like all good drawings, start with a basic shape: in this case, a circle.

**2 Add Construction Lines**
Sketch construction lines that intersect in the middle.

**3 Indicate the Iris and Pupil**
Use your construction lines to draw two circles in the center. These will be the pupil and the iris.

**4 Sketch the Eyelids**
Sketch out where the eyelids are going to be. The top lid should cover the top of the iris a bit, and overlap the bottom lid on the outside. Make sure to indicate a divot on the inside corner of the eye for the curuncula (that pink thing in the corner of your eye).

**5 Add Details**
Darken the pupil and iris and give the eye a highlight that suggests the direction of the light. Be sure to indicate the edges of your eyelids and don't go overboard with the eyelashes. A solid group of eyelashes is much more appealing than individual hairs.

## MECHANICS AND POINTS OF VIEW

The eye itself can move all over the place inside its socket to look up and down and side to side.

### The Iris Wraps Around the Form

As the eye looks to the side, the iris wraps around the form of the eyeball, making the iris appear flatter.

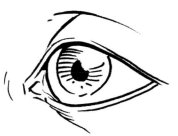

### Three-Quarters View

The three-quarters view is great to show the form of the eye. As with the face, the three-quarters view of the eye is a combination of the front and profile views.

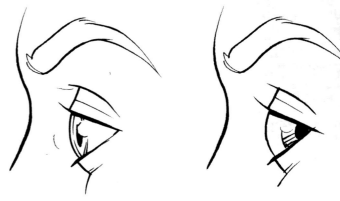

### Profile View

The form of the eyeball is much more apparent in the profile view. Notice how the eyelid wraps around the form. When looking straight ahead, the iris appears flattened or foreshortened. As the eye looks to the left, the iris and pupil become rounder again.

## FEMININE EYES

Here are a few things you can do to make the eyes you draw look feminine:

1. Draw the arch of the eyebrow higher and thin out the eyebrow.
2. Make the eye almond shaped and tip up on the outside edge (here, the right side).
3. Draw fuller, longer eyelashes.
4. Exaggerate the eyelid above the eye.

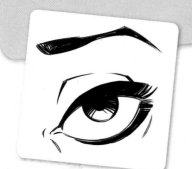

## THE EPICANTHIC EYE

Asian eyes are characterized by the epicanthic eyefold. Billions of people have this eyefold, so unless you just plan on drawing generic superheroes all your life, you'd better learn about it.

1. The eyelid doesn't wrap as tightly around the eye, but transitions more smoothly from the lids to the rest of the face. In other words, the eyes are not "sunken."
2. The eyefolds are either nonexistent or very subtle.
3. The rim of the eyelid has a smoother edge, not a hard corner.
4. The curuncula is sunk deep in the corner of the eye.

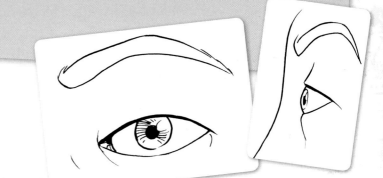

# MOVEMENT

The muscles of the eye are considerably simpler than those of the mouth. They tend to work in unison in a lot of situations, but every face is different; so, just as with the mouth, the combinations can get very interesting.

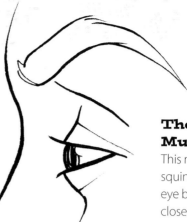

### The Squinting Muscle

This muscle controls the squinting functions of the eye by drawing the eyelids closer together.

### The Surprise Muscles

One muscle raises the eyelid, as in surprise. It commonly works in conjunction with another muscle that raises the eyebrows and wrinkles the forehead. A few talented people can use the former by itself to raise one brow at a time.

   More than anything else, white space showing between the top eyelid and the iris communicates surprise. The raised eyebrows are the icing on the cake.

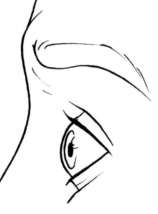

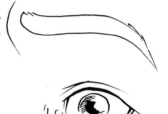

### The Angry Eye

The "frowning muscle" brings the eyebrows down toward the center of the face above the nose. It often works in conjunction with the squinting muscles.

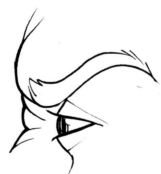

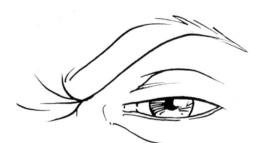

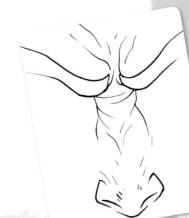

## FUN WITH WRINKLES

The frowning muscles do some really fun stuff to the nose and forehead. They are called the Corrugator muscles. They push the top of the nose into an interlocking accordion shape and pinch the forehead between the eyebrows.

   When you combine the frowning eye muscles with a sneer and an extreme frown, you get one pissed-off character! Try it out.

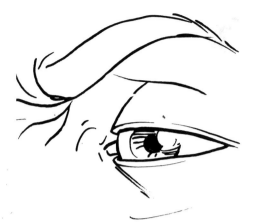

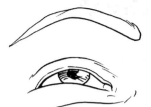

## Worm's-Eye View

This view makes a half-moon curve around the shape of the eyeball. The eyebrow sticks out in front of the eye, and the edge of the top eyelid is more distinct.

## Three-Quarters View

The eyelid follows the form of the eye as it opens or closes. Notice the huge range of motion the eyebrow has as it moves up and down.

## Big Surprise!

When the eye is in a shocked or surprised state, a worm's-eye view exaggerates the raising of the eyebrows. The head tilting away from the viewer enhances the effect.

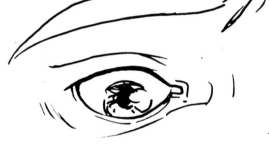

## Not So Much of a Surprise

A bird's-eye view works against the raised eyebrow here, but it still works as long as the top eyelid is far enough from the top of the iris.

## Bird's-Eye View

From a bird's-eye view, we see the reverse of much of what we saw in the worm's-eye view. This time the half-moon curve around the eyeball is flipped upside-down.

The angle of the bird's-eye view exaggerates the lowering of the eyebrow. Tilting the head down is a great way to intensify an angry emotion.

The eyebrow hangs lower over the eye, and now the edge of the lower lid becomes more visible.

# Nose

## INNOCENT BYSTANDERS

The crucial areas of the face for showing expression are the eyes and the mouth. But, understanding how the nose and cheeks change as the rest of the face moves can give that extra bit of realism and subtlety to your drawing.

### Basics of a Nose

Let's take a quick look at the nose and how to draw it using basic shapes. The basic nose shape is very similar to a wedge-shaped rubber doorstop with sloped sides.

### Beyond Smiley Faces

You can get across most simple expressions with a circle, line and two dots, but on a real face the nose and cheeks get in the way. They don't move much on their own, but are affected by how the mouth, eyes and brows move.

## Demonstration

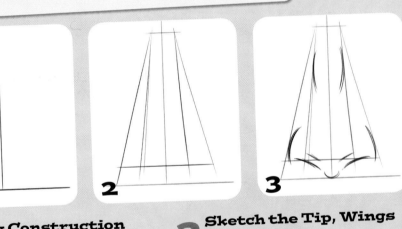

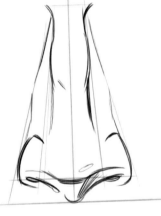

### 1 Draw Construction Lines

Indicate where the middle and bottom of the nose are located.

### 2 Draw the Basic Wedge Shape

The nose should get wider as it spreads out. The two lines in the middle tell you where the bridge of the nose is.

### 3 Sketch the Tip, Wings and Nostrils

Typically, nostrils do not face directly out. You should see slits that show only where the bottom of the nose opens.

### 4 Add Detail

Make sure to wrap your details around the form of the nose.

# Cheeks

Think of the face as a pool of water. When you drop a rock in the water, it makes a splash and sends ripples across the pool. The face works the same way. The large movements of the eyes, eyebrows and mouth act like a rock dropping in water: they send "ripples" across the face. If you read "Fun With Wrinkles" on page 32, you already saw an example of how the sneer and the Corrugator muscles do this when they scrunch up the skin on the nose.

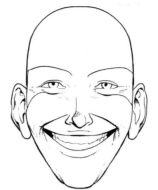

### Pushing the Cheeks Up
As the mouth smiles it will push the cheek muscles up, sometimes covering the bottoms of the eyes. Add a sneer to the smile and it'll push the cheeks up even farther.

### Breaking Up the Chin
Both the frowning and sneering muscles will cause the muscles in the chin to bunch up.

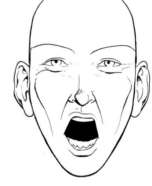

### Stretching the Cheeks
Opening the jaw will stretch out the cheek muscles and make the cheekbone more prominent.

### The Aging Face
As a face ages, the secondary details become more and more prominent. What were previously ripples now become crashing waves.

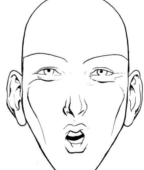

### Stretching the Nose
With the jaw open, the nose will stretch out as the lip pulls forward or under the front teeth.

# QUICK REVIEW OF THE MOST IMPORTANT INFORMATION EVER

Whew! We've pretty much covered the whole face from every conceivable angle—we hope! Just as a quick review, remember:

1. The head is a bowling ball with a beard
2. The lips are clay snakes
3. The nose is a doorstop
4. The eyes are partially peeled oranges

So, if you've been following along carefully, when you put it all together, your face should look something like this.

# Facial Variations

Hopefully your drawings won't look like freakish bowling ball, orange-eyed, bearded mutants—unless you want them to.

Now, after we've spent all this time talking about the rules for drawing faces, let's start breaking them and see what we get.

## THE HEAD
### Try these variations:

- Change the shape of the head and face. Try any random shape and then fit a cranium and face inside.

- Vary the placement of your construction lines. Keep wrapping them around the form, but place the eye line, nose line and mouth line at different levels.

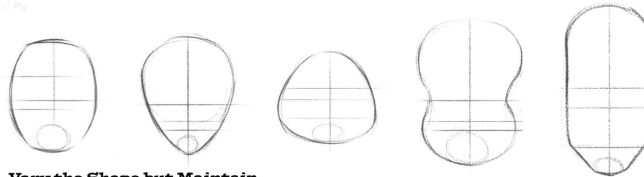

### Vary the Shape but Maintain the Centerline

You can move most of the construction lines around, but don't mess too much with the centerline. It's an important anchor for the rest of the structure.

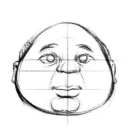
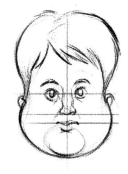
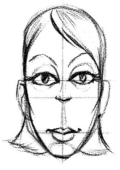

### Explore the Variations

When we add features to the face, things start to get interesting. As you vary the shape of the head, you will be naturally inspired to vary all other features on the face.

## ASYMMETRY

So far we've looked at the face as a symmetrical object: features on the right side are the same as those on the left side. Another very important way to give your drawings interest and variety is to make them asymmetrical. That means making things totally unbalanced from right to left. This can be a great way to increase the energy and instability of an expression.

## THE LIPS

Think about the thickness of the lips and the structure of the teeth underneath.

## THE EYES

Same practice here. Think about the standard form and how you could alter it.

## THE NOSE

The nose is one of the most malleable features of the face. You can start with almost any shape and transform it into a nose.

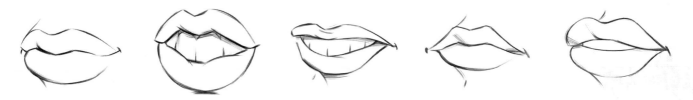

### Endless Choices

An overbite will affect the lips, and buck teeth may even force their way out. A thin top lip with a thick bottom lip can give you some great contrast. The choices are endless.

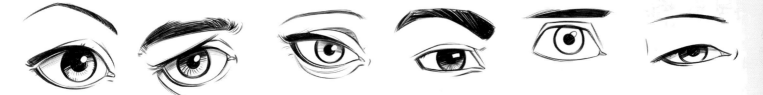

### Vary and Combine Elements

Make the eyes droop on the sides. Make eyebrows bushy or super thin. Think about what you've already looked at with feminine or epicanthic eyes, and throw that into the mix.

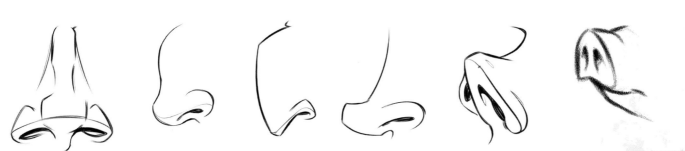

### Julius Caesar or Miss Piggy?

Think about how much you want to tilt the tip of the nose, either up or down. You can do a very hooked nose or super piggy nose.

### LET'S START EXPRESSING

Up to this point, we've pretty much just been stocking our toolbox. Now that we know what the face can do and what we can do with the face, we can start using the tools to actually create expressions. We'll refer to this section on fundamentals quite a bit from here on out, so make sure you didn't miss anything! Now, let's bring new life to your characters and start creating expressions.

# 2 Scenarios

In part two we'll start looking at creating expressions, step by step. We've included demonstrations on how to draw over fifty expressions. Because context is so important to expression, we've grouped the demonstrations into scenarios. Each scenario is a scene where we see four or five expressions from a single character as they react to the world around them.

This format gives you the opportunity to see how a face changes from expression to expression, and to learn how expressions can help move a story along, frame by frame, in comics books, animation and other forms of visual storytelling.

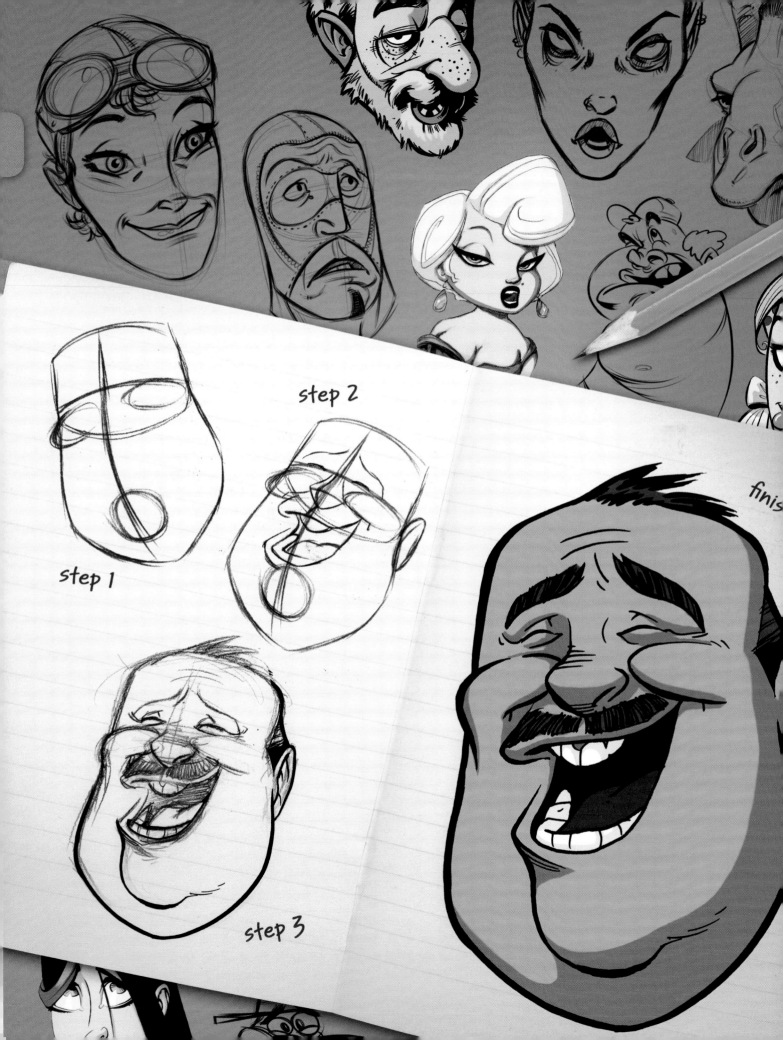

step 1

step 2

step 3

finis

# Billy Finds a Flower

We'll start our scenarios by telling the story of Billy finding a flower.

Brandon will show you how to draw some simple expressions such as

happy and sad, but will also introduce some subtle variations.

## ARTIST'S NOTE

I wanted to start with some expressions that are simple and generic. That way, when scenarios later in the book show more subtle variations, there's something to build on. Because we're looking at simple expressions, I also wanted to use a simple character design that is easy to understand and duplicate in terms of structure and form.

The expressions for this scenario are also exaggerated to make them clear and readable, and to make the elements that typify them obvious.

That's why Billy's eyes and mouth are gigantic. Since most expressions are communicated through the eyes and mouth, it should be **very** easy to see what's going on.

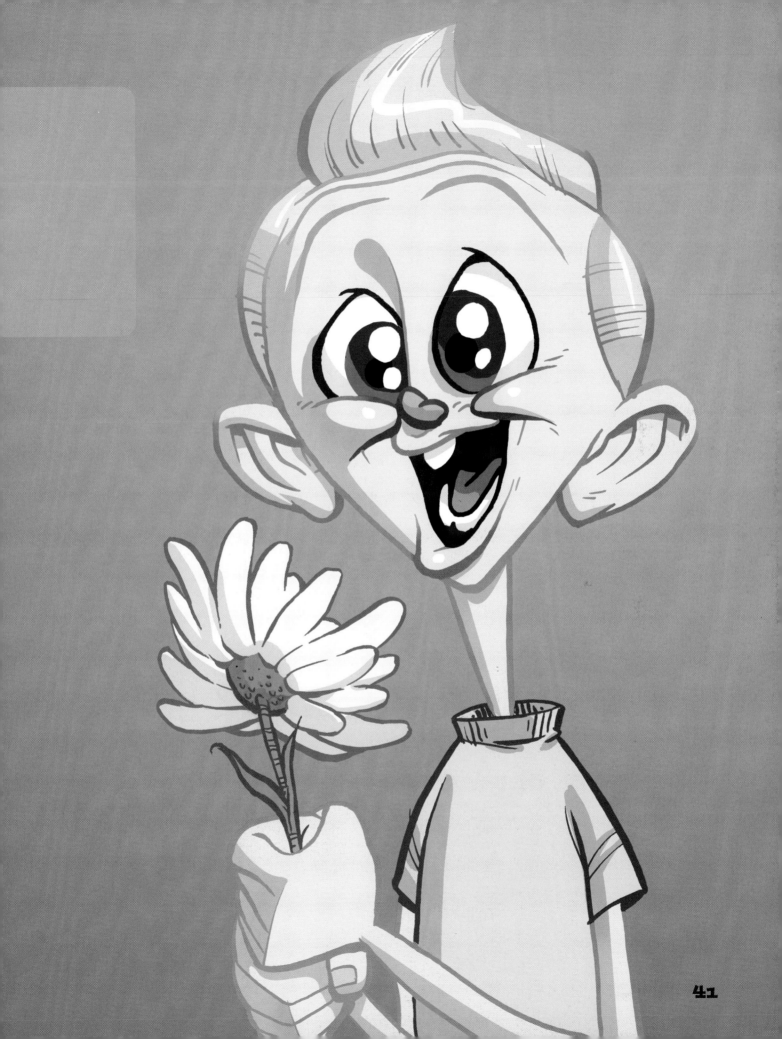

# HAPPY

Billy is a pretty generic character. He's an innocent, well-meaning kid—nothing too specific or unique there. He provides a good place to start creating simple expressions.

Let's suppose Billy is strolling through a lovely meadow. The air is crisp and fresh. A smile breaks out across Billy's face.

### 1 Draw the Basic Structure
Draw a simplified version of the head shape on page 20. The cranium in this case is a squashed oval, and the jaw is pointed. Draw your construction lines, indicating the middle of the head and the eye line.

### 2 Rough In the Features
Make the features a little bit asymmetrical. Draw the corners of the mouth pulled up in a smile, and give the smile some twists and turns to show he's kind of sticking out his bottom lip, too. Draw his eyes big and wide, and place his irises close together to show his naive and goofy personality.

### 3 Add Details
Now that you've got the main features roughed in, start adding details. Remember to wrap your details around the form. Use them to describe the bigger shapes. Draw in his hair. It's like a tidal wave cresting on top of his head. Add the eyebrows. They're raised to accentuate his wide-eyed stare.

### 4 Clean Up the Sketch
You can use felt-tip markers, a brush and ink, or clean up the drawing digitally. I used felt-tip markers and a brush marker here.

Use thicker lines for the larger shapes, and thinner lines for smaller shapes. Also, use thick lines for areas of focus, such as the eyes and mouth. Use your smallest lines for details that describe the form, such as the detail of Billy's hair and the lines on his forehead.

### 5 Add Color
I wanted to use color that would work for animation, and I wanted it to feel as though Billy were being bathed with sunlight. To give it the animation feel, all the shadows have an equally hard edge; there are no subtle changes in value. This also helps sell the daylight feeling. The colors in the shadows are warmer than the colors in the light areas, which also helps to make it feel like daylight.

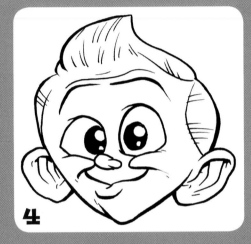

4

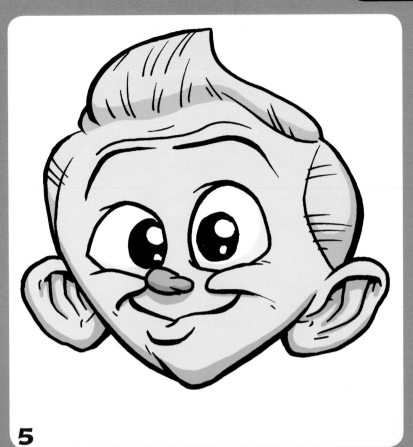

5

## Happy Variations

**Bronze**
I tried to think of the happiest person I know ... and here he is.

**Gibbs**
When I was drawing this I was thinking that **happy** can be pretty simple, if not subtle.

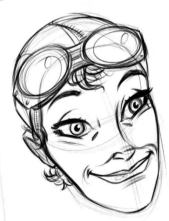

**Ben**
Happiness comes in all different ways. Hers just happens to come from shooting down the enemy in a deadly 1920s aerial dogfight. Isn't she pretty?

# JOYFUL

Billy has just encountered a pristine, perfectly formed flower. It fills his heart with immaculate joy.

JOYFUL and HAPPY are pretty similar expressions, so this is where getting more subtle and specific is important. Ask yourself how this expression is different from happy. What's going through Billy's mind that's different from the last demo?

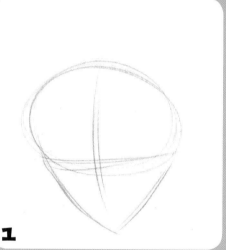

**1**

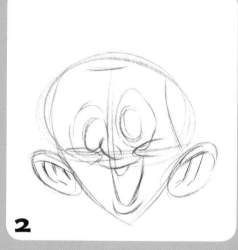

**2**

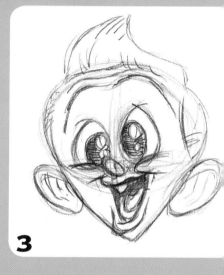

**3**

## 1 Draw the Basic Structure

Start with the simplified head shape we used in the last demo, but give the jaw some more length. The mouth is going to open on this one, so you want to stretch the face out. Add your construction lines.

## 2 Rough In the Features

Make the expression "bigger" than the last demo. Draw his eyes wider, his eyebrows higher, and open his mouth to exaggerate the smile. Draw his cheeks squished up higher in his face by the power of his smile. Indicate the details inside his mouth.

## 3 Add Details

Think of your drawing as if you were throwing a rock in a pond. The big shapes are the rock; they go in first and send ripples of details across the face. Indicate how the movements of the big shapes pull and twist the face around them. Finally, add Billy's shock of hair.

## 4 Clean Up

Clean up the artwork as for the previous demo. Make sure your lines taper at the ends. This will make them feel like they're wrapping around the form instead of lying flat on the paper.

## 5 Add Color

Use the same coloring scheme as for the previous demo, and voilà! You've got a happy kid.

**4**

**5**

# Joyful Variations

### Gibbs
When illustrating this I was thinking that joyful is much bigger and more obvious than **happy**.

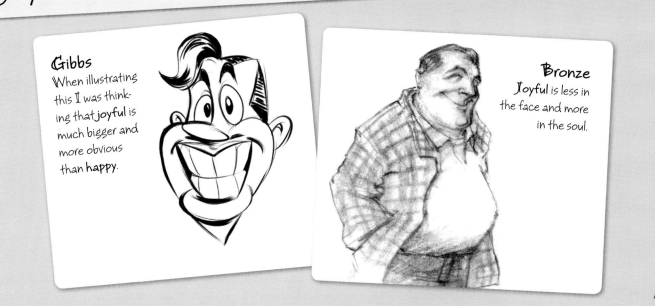

### Bronze
Joyful is less in the face and more in the soul.

# ABOUT TO SNEEZE

What Billy doesn't know is that he's allergic to flowers. He picks up the flower and gets a big hearty snoutful of pollen. He tries to hold back a sneeze but he can feel it coming.

In this demo, you're going to draw an involuntary bodily reaction. Any emotion Billy is feeling here is obscured by his body telling him he's got to sneeze.

**1**

**2**

**3**

**1 Draw the Basic Structure**
Start with the modified head shape again. Squash it a little bit to show the tension Billy's face is holding before he sneezes. The head is also going to be tilted back here, so rotate your eye line up a bit.

**2 Rough In the Features**
Make the features asymmetrical to show the high energy and imbalance of this expression. Draw his lips puckering out to one side. Draw his nostril flaring to show that he's inhaling before he sneezes.

**3 Add Details**
Wrap the eyelids around the form of the eyes, and darken the mouth to show depth. Add the hair.

**4 Clean Up**
Clean up the drawing as for the last two demos. Add smaller detail lines around the points of tension in his face.

**5 Add Color**
A little color finishes things off. Now all you have to add is the prairie animals running for cover.

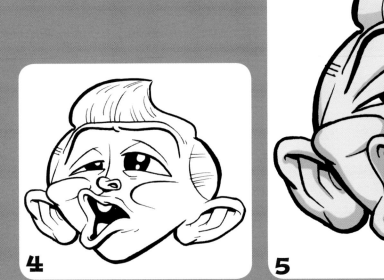

4

5

## Sneeze Variations

### Gibbs
Getting ready to sneeze can be pretty tricky. The face can contort and twist in so many ways that it might be said that the more asymmetrical you can make the face, the better.

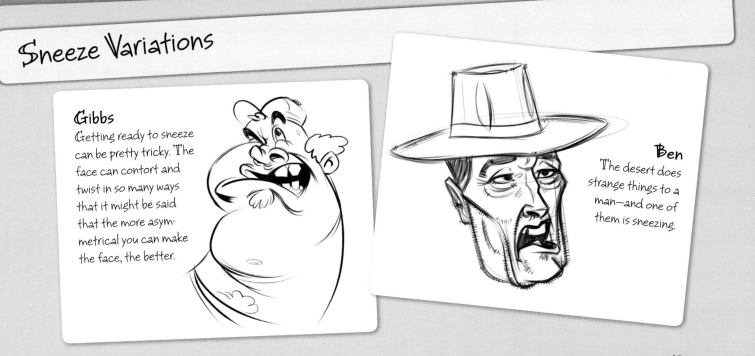

### Ben
The desert does strange things to a man—and one of them is sneezing.

# SAD

Billy, with a single sneeze, has now destroyed the one thing he loved the most. The flower that had once filled his heart with joy is now a ruin of scattered petals. The grief is more than Billy can bear.

**1**

**2**

**3**

## 1 Draw the Basic Shape
Start with an oval head shape. Draw the construction lines so that the eye line is at a normal level again.

## 2 Rough In the Features
Draw the shape of the eyes with the eyelids closing on the irises. Draw a standard frown mouth shape, with the corners pulled down.

## 3 Add Details and Strengthen Forms
The eyebrows are important here. Draw them so that they push up the middle of the head. Strengthen the most important forms, especially the eyes and the mouth. Add indication of the teeth inside the mouth. Finish with the soft-serve ice cream hair.

## 4 Clean Up
Once again, clean up the expression. Keep your focus on the overall shape of the face and the important elements of the expression. Add details around the eyes, on the cheeks and on the chin to describe the tension in the form.

## 5 Add Color
You can use your coloring to make the forms more three-dimensional. Shadows should do the same thing as details on the face: wrap around the form.

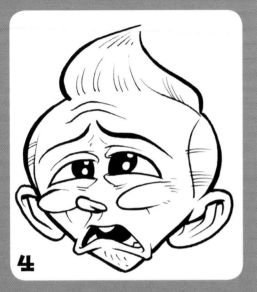

**4**

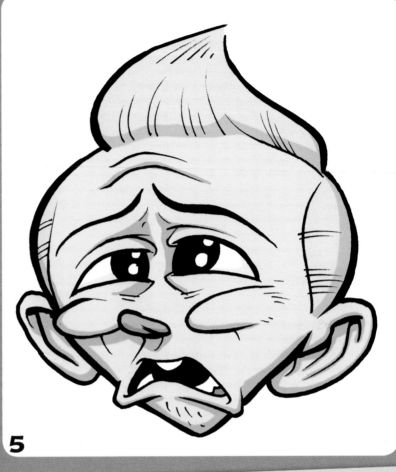

**5**

## Sad Variations

### Gibbs
Sad can also vary depending on the context of the character. Here it's as if he just found out that his goldfish died.

### Ben
He finally broke down from the barrage of fat jokes, and then everyone felt severely ashamed.

### Bronze
His kitten ate his goldfish and then his kitten died. Sad.

# The Villain

In this scenario, Gibbs will explain how to properly draw the facial expressions of a villain. We'll develop faces that look angry, deep in thought, conniving and, finally, possessed. We will then see who is possessed with the spirit of a great artist.

## ARTIST'S NOTE

When I approached work on the various expressions of a villain, I immediately decided to go with someone who was intellectual and clever. I thought that he would be the perfect foe for a brutish hero.

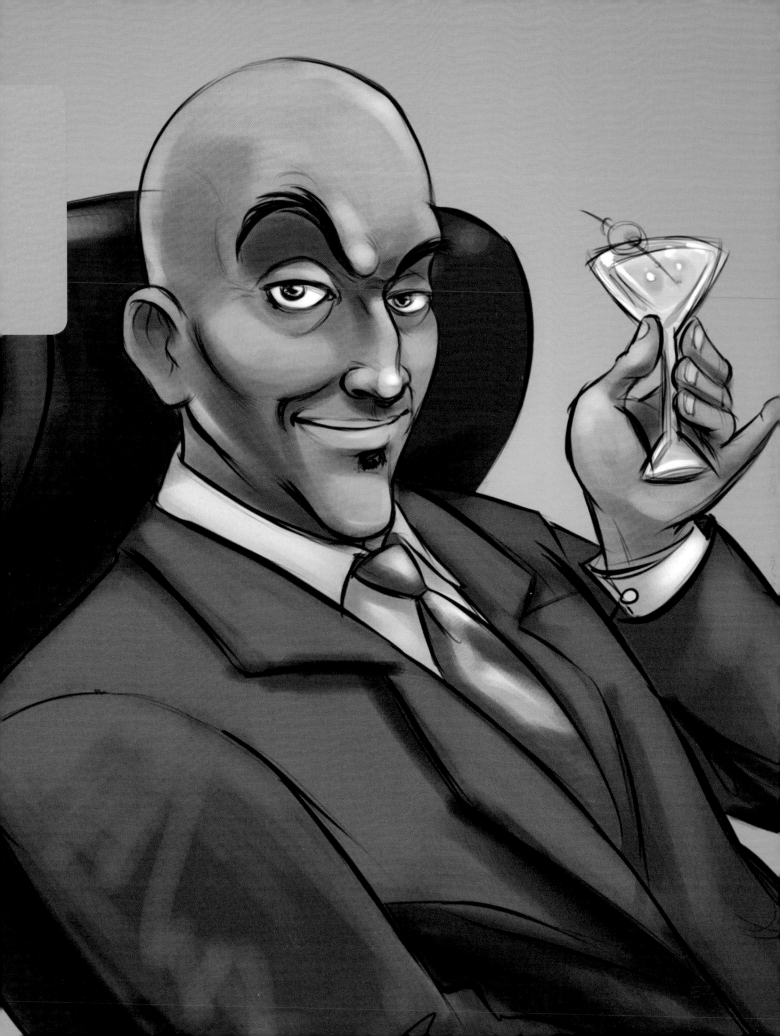

# ANGRY

The villain has been foiled by the hero once again, and he is angry. Once I was foiled; I was so furious it took three grown men and one orangutan to snap me out of it.

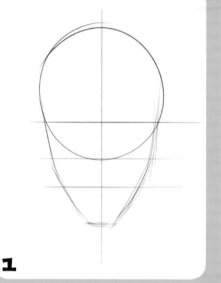

**1**

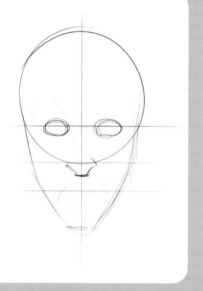

**2**

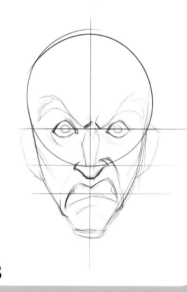

**3**

### 1 Draw the Structure
Draw a circle for the cranium and a U-shape for the jaw. Add construction lines for the eyes, nose and mouth.

### 2 Rough In the Features
Lightly draw the shapes of the features. A squinched brow and lowered corners of the mouth express anger. I gave him an open mouth to make him look even more angry.

### 3 Add Details
Add detail to the nose and eyes. Leave some white showing between the irises and the eyelids to show the intensity of the expression.

### 4 Refine the Form
Refine the form of his face by adding some contours to the sides using thin and thick strokes. Add more details to the ears and face.

### 5 Clean Up
Darken the lines and add subtle shading to define the contours.

### 6 Add Highlights and Shadows
Make sure you know where your light source is so you know where to put the shadow. Wrap the shadow and light around the form so it doesn't look flat.

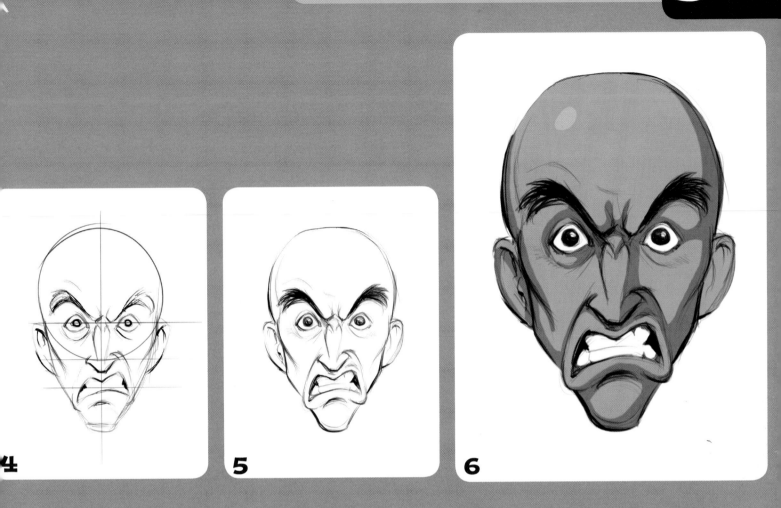

**4**

**5**

**6**

# Angry Variations

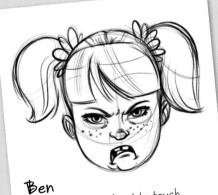

### Ben
They were warned not to touch Polly's princess scooter. Now they're gonna pay.

### Bronze
Apparently long noses and anger mix well.

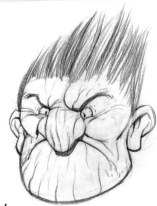

### Brandon
To me, anger is all about tension. I wanted to use all the details to show how angry energy is compressing his face into a tight packet.

**53**

# DEEP IN THOUGHT

The villain tries to figure out what he can do for revenge. He slowly formulates a plan to cover the hero's toilet seat with plastic wrap—that'll get 'im.

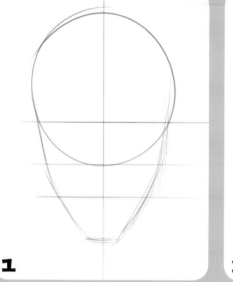

**1**

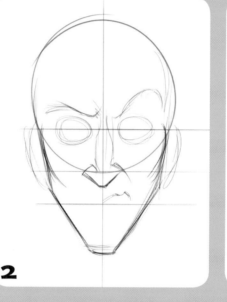

**2**

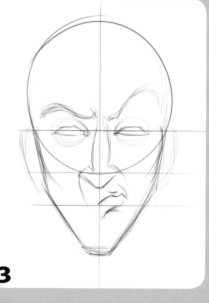

**3**

**1 Draw the Basic Structure**
Draw a circle for the cranium and a U-shape for the jaw. Add construction lines for the eyes, nose and mouth. Starting to sound familiar?

**2 Rough In the Features**
Lightly draw his pointy nose, eye sockets and tight lip. Give him one raised brow. Add a hint of form in the head.

**3 Add Details**
Draw squinting eyelids and add lines around the nose and mouth to show how the mouth is pushed out toward the side. He is frozen in thought.

**4 Refine the Features**
Draw the eyeballs looking toward the side to indicate that he's thinking deeply and seriously. Add slight details to the ears and face.

**5 Clean Up**
Add details using a stroke that varies in width to bring in interest. Darken lines and add shading if desired.

**6 Add Color**
Color and lighting can set a mood. To make things really dramatic, or to create a "horror" moment, color it so that the light source appears to be below or to the side.

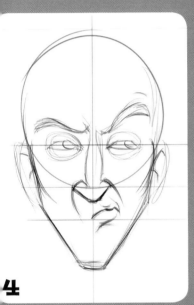

**4**

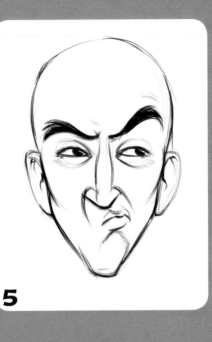

**5**

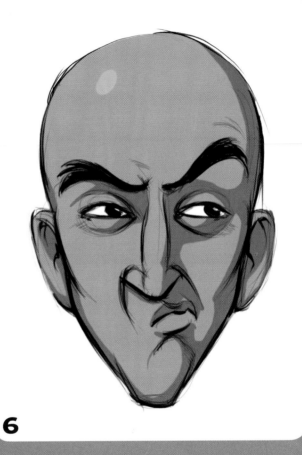

**6**

## Deep in Thought Variations

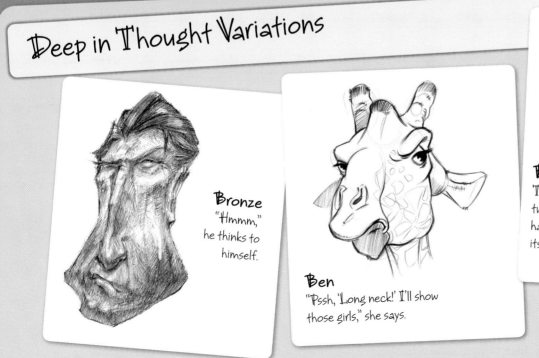

**Bronze**
"Hmmm,"
he thinks to
himself.

**Ben**
"Pssh, 'Long neck!' I'll show
those girls," she says.

**Brandon**
There's some sort of link between a
twisted up mouth and thinking. I still
haven't found the exact connection, but
its fun to play with anyway.

# CONNIVING Now that
he has an idea that pleases him, he begins to work it out in his head.

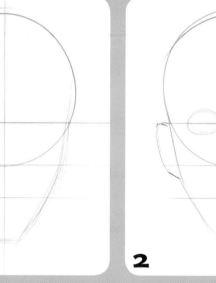

**1**

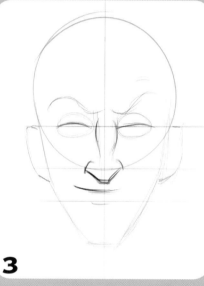

**2**

**3**

### 1 Draw the Basic Structure
The third time's a charm. Draw a circle for the cranium and a U-shape for the jaw. Add construction lines for the eyes, nose and mouth.

### 2 Rough In the Features
Lightly draw the eyes as ovals and the shape of the nose and ears.

### 3 Add Details
Add heavy lids and a raised brow to indicate that he knows something we don't.

### 4 Refine the Features
Draw the smile and add some more form to his face. Add slight details to the ears and face.

### 5 Darken and Clean
Darken and clean up the lines, using thicker lines where your shadows will be. Notice how the villain's left cheek wrinkle is darker than his right. Look out, hero!

### 6 Add Color and Shadows
Reflect the mood with your color choices and shadow placements. If you add too much green, or de-saturate him, he might look ill.

4

5

6

## Conniving Variations

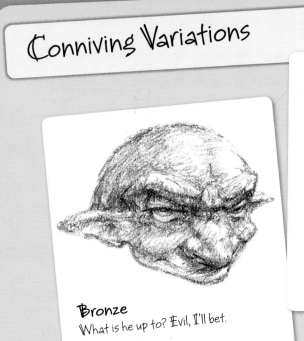

**Bronze**
What is he up to? Evil, I'll bet.

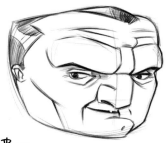

**Ben**
"I am going to make so much money off of these paper toys," Rudy "The Brut" thinks to himself.

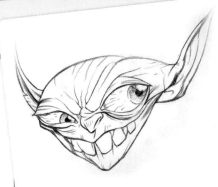

**Brandon**
This is one of those sketches that was drawn intuitively. Sometimes going with a gut impression is best.

# POSSESSED

He's intoxicated by the cunning of his plan. I'm sure they make pills for what he's got.

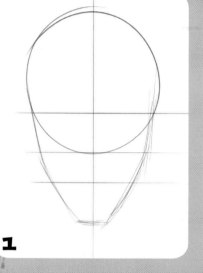

**1**

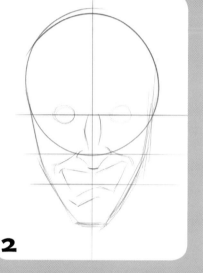

**2**

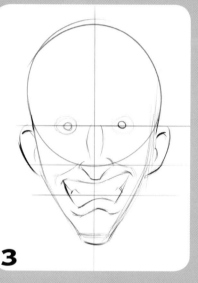

**3**

## 1 Draw the Basic Structure
Draw a circle for the cranium and a U-shape for the jaw, then add construction lines for the eyes, nose and mouth. Beginning with this structure is the key to drawing the same character over and over again and keeping it consistent.

## 2 Rough In the Features
Lightly draw the eyes as ovals and the shape of the nose. Then add a bit of craziness by drawing a mouth with the corners curled up for a demonic smile.

## 3 Add Details
Draw his eyeballs and give shape to his teeth.

## 4 Refine the Features
I know we've drawn lots of raised eyebrows. Draw them again. Define the lower lip and the raised cheeks to make room for the smile. Add slight details to the ears and face. Also, draw one eye squintier than the other.

## 5 Clean Up
Give form to the face with your thin and thick contours. Don't overwork it. Sometimes too much detail can be bad.

## 6 Add Color
When coloring a character in a scene, be sure to consider his surroundings. Outdoor light will give his skin a different tone than indoor light.

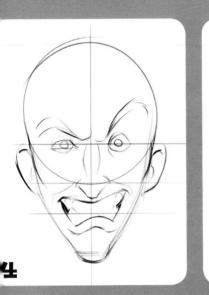

**4**

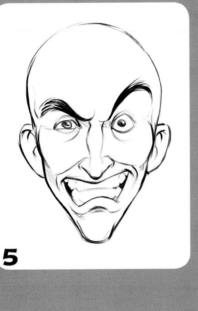

**5**

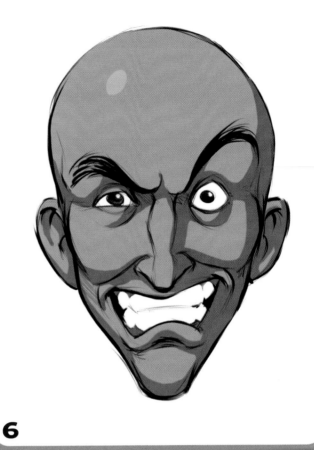

**6**

## Possessed Variations

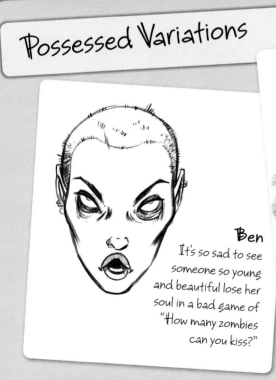

### Ben
It's so sad to see someone so young and beautiful lose her soul in a bad game of "How many zombies can you kiss?"

### Bronze
He's got that look in his eye again.

### Brandon
My concern with this expression was to avoid making him look surprised. I think the difference is that a surprised look focuses on something specific. I tried to draw the eyes here as if they're looking off into the distance, more focused on the inward mental state.

# Stages of Fear

In this demo, Brandon will use a typical security guard character to walk you through a range of emotions associated with fear. Starting with laughter, the situation will deteriorate into dread, terror and finally horror as our character's composure slowly unravels.

## ARTIST'S NOTE

I wanted to take a different approach for this scenario than I did for the one with Billy. The design for the security guard is more realistic, and more along the lines of what you would see in a superhero comic.

Like Billy, the security guard is expressing some strong feelings, so the expressions shouldn't be too hard to read—but there are definitely more subtleties here. I especially liked trying to differentiate between **horror** and **terror**. I think looking at the details that distinguish them is a worthwhile exercise.

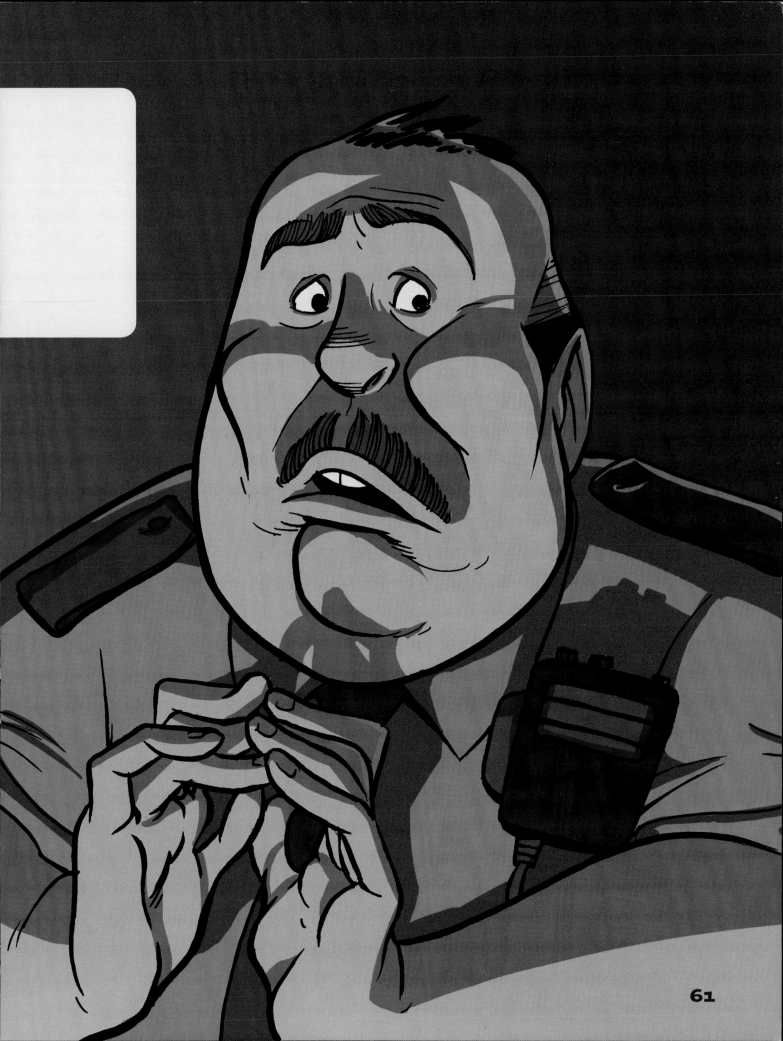

# LAUGHTER

We're going to be looking at fear in just a bit, but to start let's do an expression that contrasts sharply with fear: laughter. It's a relaxed, safe and confident expression, so when we switch to fear, the contrast will make the fear seem even stronger.

Let's say the security guard is on the radio with one of his buddies, joking about how bad his wife's cooking is. He lets out a hearty laugh.

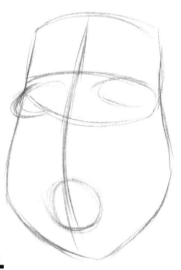

**1**

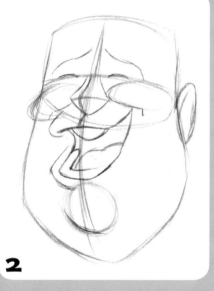

**2**

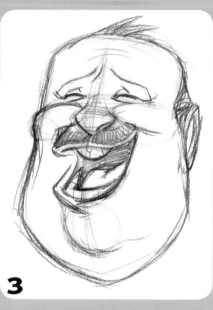

**3**

### 1 Draw the Basic Structure
Make the cranium more like a square block than a sphere. Next, make the jaw line a big fat U-shape to make room for his double chin. Add your construction lines. The eye line should fit inside the cranium. Offset the centerline for this modified three-quarters view. Using the centerline as a guide, indicate where the actual chin sticks out of the double chin. Rough in the large masses of the cheeks.

### 2 Rough In the Expression
This is where you need to spend the most time to get it right. Draw the eyes closed with simple curves. Draw the nose, indicating the form of the nose with construction lines. Add a smile. This is very similar to the smile on page 44: wide-mouthed and pushing up the cheeks. Indicate the placement of the ears.

### 3 Add Form and Detail
Reinforce the important forms with thicker lines. Thicken the lines under the chin to emphasize its weight. Indicate the shape of the eyeballs under the eyelids by having the eyefolds sink into the face. Add detail to the mouth, with a horseshoe shape to show the form of the bottom teeth and a half-moon shape for the top teeth. Add the hair and mustache, wrapping them around the shapes you've already established.

### 4 Clean Up
For this demo you can use a brush marker and other felt-tip markers or you can clean up your drawing digitally. Darken the areas of emphasis, and draw thicker lines at the bottoms of shapes to give them weight. Use your smallest strokes to show the little details.

### 5 Add Color
No big surprises: just some warm colors. I used hard edges rather than subtle shading to give it an animation look. To give it some extra pop, you could color the lines.

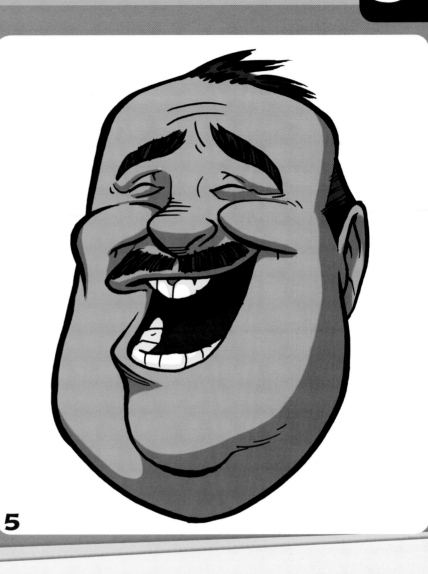

**4**

**5**

## Laughter Variations

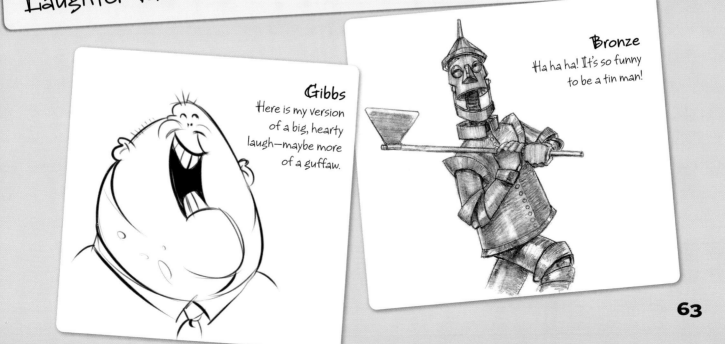

**Gibbs**
Here is my version of a big, hearty laugh—maybe more of a guffaw.

**Bronze**
Ha ha ha! It's so funny to be a tin man!

# DREAD

All right, let's do some fear now. We're going to start with DREAD. Dread is the anticipation of something unpleasant. It's imagining all the terrible things that the sound downstairs could be. It's easily the most interesting of all the fear emotions, because you can draw it out forever. So, after having a laugh with his pal, Mr. Guard hears a sick noise. His blood runs cold.

**1**

**2**

**3**

### 1 Draw the Basic Structure
Start with the block-shaped cranium and massive U-shaped chin. Add construction lines.

### 2 Rough In the Features
This expression needs to show potential: energy in reserve. He's scared, but trying not to let fear overcome him, so the expression won't be big. Rough in the nose with construction lines. Draw the mouth with the corners dropped to show a hint of distress. Draw the eyes with the pupils looking in the direction of the creepy noise. If his whole head were turned in the direction of the noise, it would imply confidence. With only the eyes changing direction, we see not only his concern with the noise, but also his hesitation to confront it. Draw his eyebrows raised in distress, and elongate the shape of the cheeks to show them being pulled down by the mouth.

### 3 Add Details
Extend the shape of the cheeks to show how they interact with the frowning mouth. Add shape and a nostril to the nose and detail lines wrapping around, radiating out from the larger forms. Again, finish with the hair and mustache following the direction of the forms of the face.

### 4 Clean Up
Ink the drawing as in the previous demo. Indicate the hair with big, fast brushstrokes. If you're drawing on bristol board, it helps to wear a cotton glove with the fingers and thumb cut out. This will keep your hand from sticking to the surface and will help you make long, smooth strokes.

### 5 Add Color
Once you've established a color scheme, this step should be easy. Pay attention to details, such as how the shadows wrap around the form.

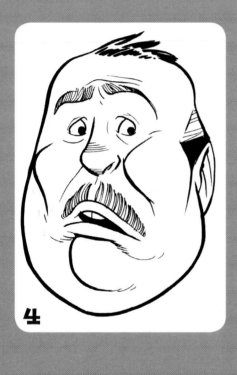

4

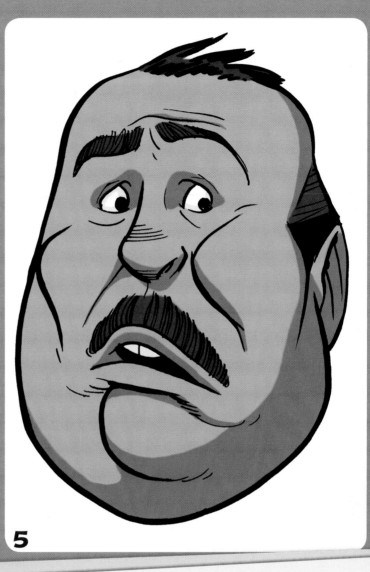

5

## Dread Variations

**Gibbs**
I thought of **dread** as if the character were looking around expecting someone to creep up on him.

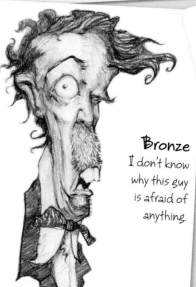

**Bronze**
I don't know why this guy is afraid of anything.

**Ben**
El Guapo looks up with dread as the two-ton El Smasho jumps off the top ring.

# TERROR

Now, let's suppose our security guard finally got the guts to investigate the strange noise. He warily probes a utility closet with his flashlight shaking in his hand. All of a sudden, a mangled corpse drops from the ceiling. The shock of the noise makes his hair stand on end and he jumps back.

This is TERROR. Terror is an extreme but momentary feeling at the climax of an unpleasant surprise.

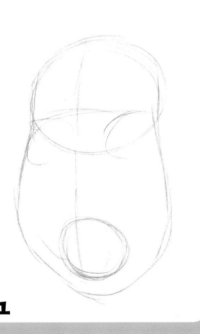

**1**

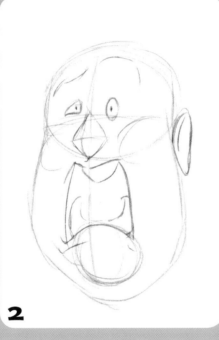

**2**

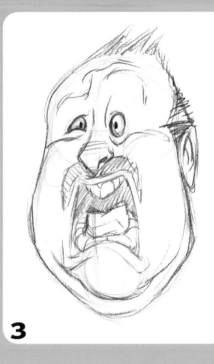

**3**

## 1 Draw the Basic Structure

Start with the cranium and jaw shape. Elongate the jaw this time, and push the real chin down farther into the double chin. Add the construction lines.

## 2 Rough In the Features

Draw the mouth as big as possible. Indicate the horseshoe shape of the bottom teeth and the half-moon of the top teeth. Pull the eyebrows up and the eyes open, but make them asymmetrical. This will help to make the expression look more out of control and energetic.

## 3 Add Details

Add a lot of details wrapping around the bigger forms to show the energy and exaggeration of this expression. Pay particular attention to how the eyebrows push up the forehead, and how the chin and corners of the mouth push down on the bottom of the face and the double chin. Add the mustache and hair, making the hair stand on end to elongate the pose and add more energy to the moment.

## 4 Clean Up

Use single, bold strokes originating from the wrist or elbow to ink over your sketch. Practice strokes on the side of the drawing before you commit to the cleanup.

## 5 Add Color

Color is the icing on the cake. If you've created an effective drawing, coloring it is no sweat.

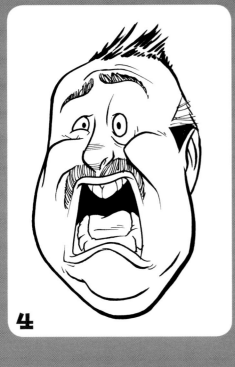

4

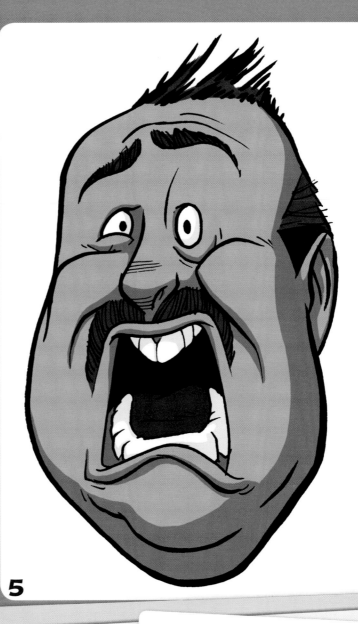

5

## Terror Variations

**Ben**
A flesh-eating salty lake! What are we going to do?

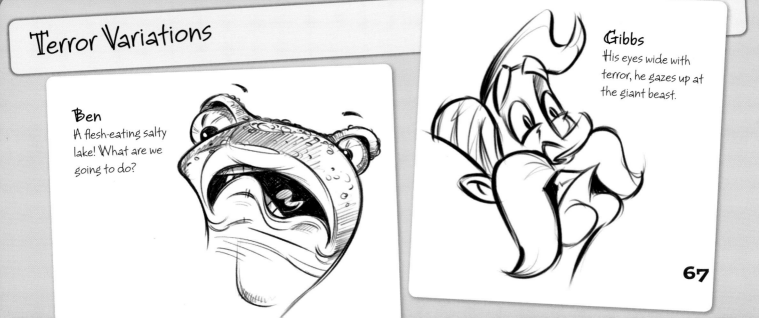

**Gibbs**
His eyes wide with terror, he gazes up at the giant beast.

# HORROR

Now that Mr. Guard is past his initial shock, he stares in horror at the mangled corpse. HORROR is contemplative; it occurs as the mind tries to process some sort of terrible image or piece of information. If the mind can't get a grasp on it, the horror continues or may escalate toward a panic. Horror can last longer than terror, but because it still takes a lot of energy, you can't draw it out as long as dread.

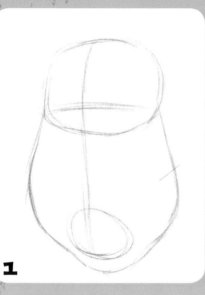

**1**

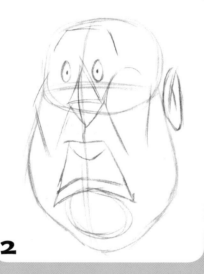

**2**

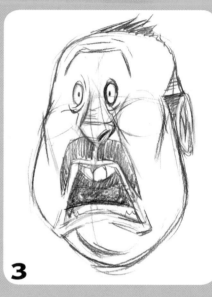

**3**

### 1 Draw the Basic Structure
Keep the face elongated because the mouth is going to be open again.

### 2 Rough In the Features
The eyes are still open and eyebrows raised, but less asymmetrical than in the last pose. Rough in the nose. It'll be elongated as the mouth and eyes pull on it from either end. The same goes for the cheeks. Make the mouth more relaxed than terror, but still drop the jaw and give him a good frown.

### 3 Add Details
Even though his mouth is open as wide as for terror, cheat the intensity of the expression by drawing the bottom row of teeth flat, instead of in the horseshoe pattern. Add details above the eyebrows as well as the hair and mustache.

### 4 Clean Up
Clean up just as you've done in the previous demos.

### 5 Add Color
Apply color as you did for the previous demos. Notice that the shadows around the eyes and nose are less exaggerated than they were for terror. Flip through what you've done. It's almost like watching a cartoon.

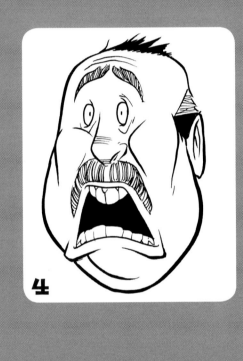

**4**

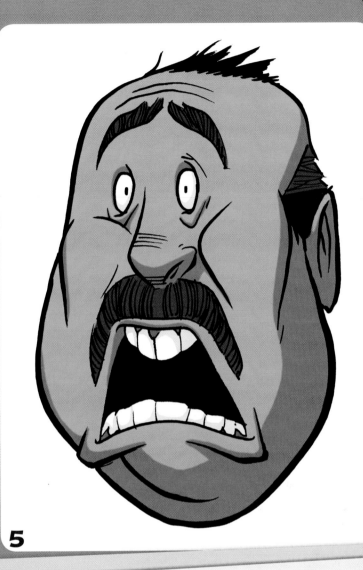

**5**

## Horror Variations

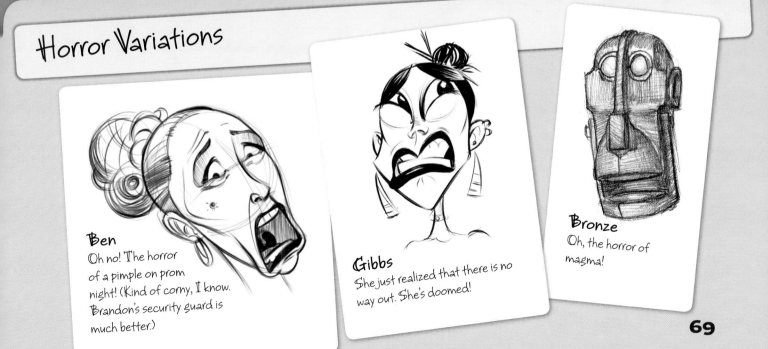

**Ben**
Oh no! The horror of a pimple on prom night! (Kind of corny, I know. Brandon's security guard is much better.)

**Gibbs**
She just realized that there is no way out. She's doomed!

**Bronze**
Oh, the horror of magma!

**69**

# Tuna for Lunch

"Not again!" says Joey as he opens up his lunch box. "This is the third time this week!"

Let's learn along with Bronze as he stylistically shows us a glimpse into the dreadful daily life of a sixth-grader. We will explore his subtle expressions when something stinks, when he feels disgusted, when he feels annoyed and, finally, when he's utterly hopeless.

## ARTIST'S NOTE

I'm not going to lie. Drawing kids or youth is not my strength. I like drawing old people—wrinkly, ugly, old people because they have a lot of features to work with. Kids, on the other hand, have smooth, round faces, and if you throw in too many wrinkles or if they're too deep, then suddenly the kid you're drawing looks like he's forty.

For reference, I turned not to a mirror with my ugly face in it, but to the World Wide Web for images of kids making the expressions I was after. Stock photography sites are a good resource, as are the sites of child photographers. Remember to use the images you find only as references; don't copy the pictures directly. References can help you stretch and develop your skills, but your drawings should be unique. All right—that's enough talk. Let's draw a kid!

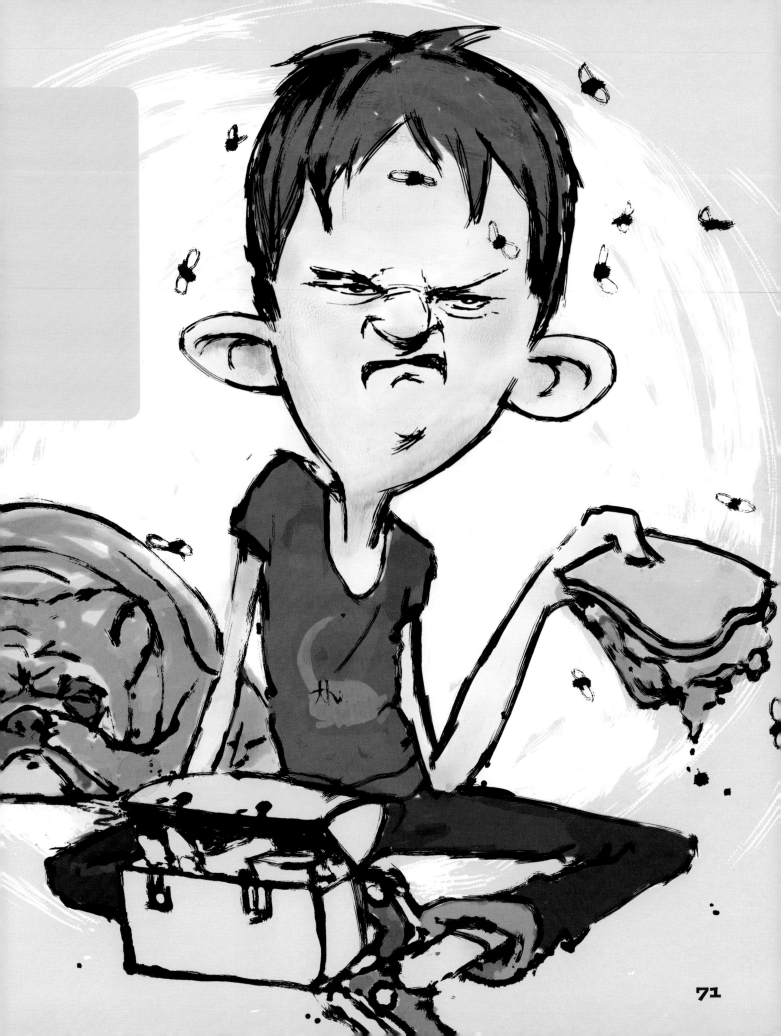

# SOMETHING STINKS

Joey is like any kid: he enjoys a good sandwich. But today his mom threw a tuna sandwich into his lunchbox. "Why?" he asks, knowing there are perfectly good meats like bologna to choose from. As he peers inside his sandwich to assess the damage, the stink of tuna hits his nostrils, sending Joey's giant head rearing back.

Kids like Joey have some of the most expressive faces of all humans, but without the deep facial lines found on adults. Let's stretch and squash his face to get the expressions we need.

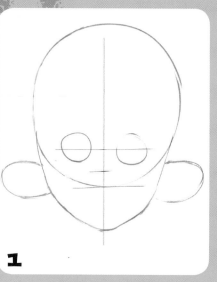 **1**

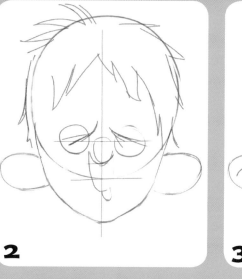 **2**

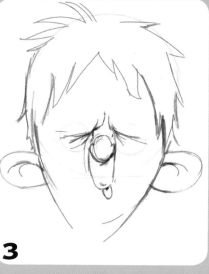 **3**

## 1 Draw the Basic Structure
Start with the basic head structure, using a circle for the cranium and a soft V-shaped jaw with the sides angled toward a smaller chin. I drew huge ovals for Joey's ears, which makes him look goofier and younger. Draw construction lines for the eyes, nose and mouth. Kids generally have big craniums and smaller, rounder jaw lines. Notice how small his features look in relation to his giant cranium.

## 2 Rough In the Features
Draw circles for his eyes fairly close to the centerline. Draw a long oval for his nose since he's pulling it up and pinching it to avoid more stench. I moved his lips down and puckered them by making the upper lip a subtle U-shape and the lower lip a little oval underneath it. Draw two diagonal lines pointing inward and upward for his eyebrows, and just below those, two smaller diagonal lines tilted just slightly more downward. Draw some shaggy hair just off his noggin.

## 3 Add Details
Add wrinkles for his nostrils, making them look pinched. Draw more lines around his eyes to create a tight, squeezed look, and add some wrinkles above his nose to show it's being pushed into the bridge between his eyes. A little U-shape above his upper lip makes his lip look more pushed out than tucked in. Add a few arching lines in the ear to roughly suggest ear anatomy. (Take some time to look carefully at an ear. Mentally break it up into simple shapes so you can later refer to those shapes in your head.)

## 4 Clean Up
Now, let's clean this drawing by inking over your pencil lines. I like to use a messy ink brush because it gives extra personality to my lines, and it works well with a drawing that's supposed to look stinky. You may want to make a few copies of your pencil drawing and practice inking over those until you get a good feel for your inking process. After the ink dries, erase your pencil lines.

## 5 Add Simple Color

For color, just throw on something to give it texture—nothing fancy. This character is a little more stylized and I want that to come through more than any color scheme.

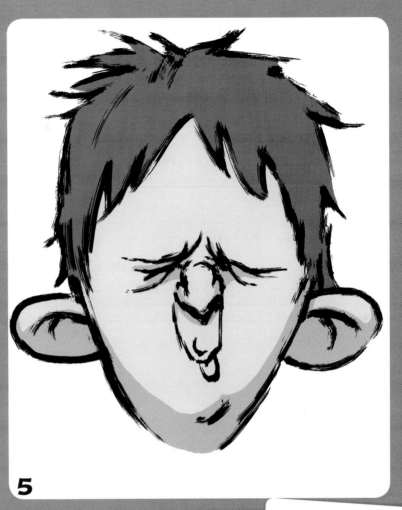

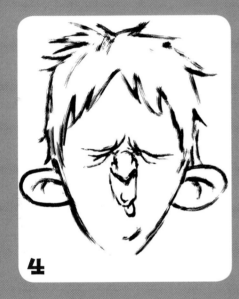

4

5

## Something Stinks Variations

**Gibbs**
Perhaps he smells himself.

**Ben**
Nothing better than Mr. High & Mighty realizing that, after blaming everyone else, it's him who stinks.

**Brandon**
I wanted to try something more subtle here. Maybe I should have added a stink line wafting into his nostril, or made him cross-eyed.

# DISGUSTED
Now that the stink has made it into Joey's brain, he stretches his mouth open and sticks his tongue out in disgust.

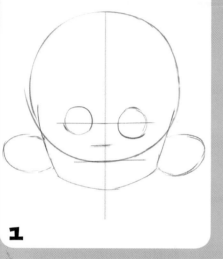

**1**

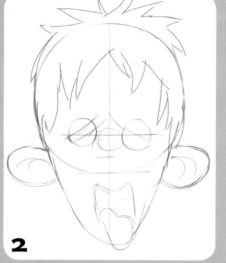

**2**

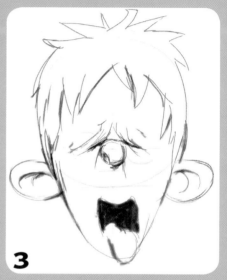

**3**

## 1 Draw the Basic Structure
Draw in the head structure. I usually draw the jaw where it would normally be in a closed position, and then draw a second jaw line later to figure out a good range of motion.

## 2 Rough In the Features
His eyes and nose are similar in this expression, pinched in toward the centerline of his face. Notice how I've drawn a second jaw line down further to accommodate an open mouth. I moved his lips down again and then opened his mouth with downward lines. His lower lip is hidden by his tongue which is hanging out of his mouth. I didn't push the tongue out too far to avoid making him look as though he's about to vomit.

## 3 Refine and Add Details
Open up his nostrils now, but keep the oval, pinched look. Add lines around his eyes to create that tight, squeezed look and a few frown lines above his eyebrows to show tension in the eyes. Draw even stronger wrinkles above his nose to show it being pushed up.

## 4 Clean Up
Finish by inking over your pencil lines, trying to follow the most important and strongest pencil lines you've made.

## 5 Add Color
Add a little color to give this bad boy some life.

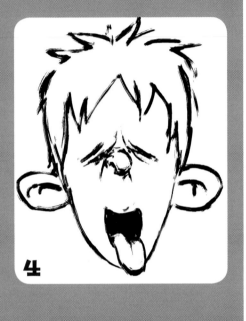

**4**

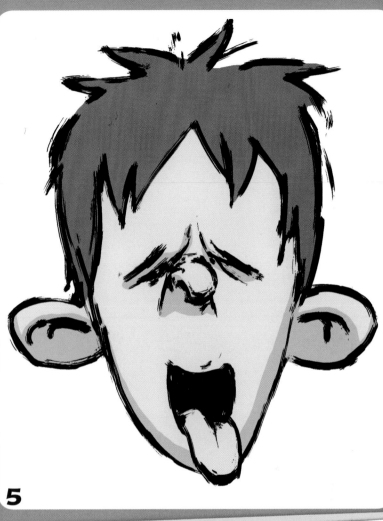

**5**

# Disgusted Variations

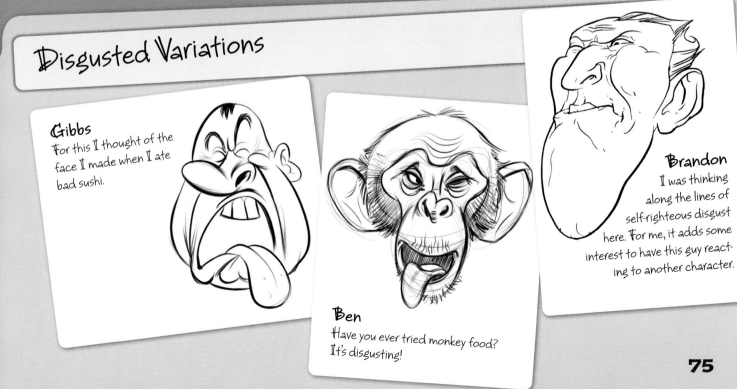

**Gibbs**
For this I thought of the face I made when I ate bad sushi.

**Ben**
Have you ever tried monkey food? It's disgusting!

**Brandon**
I was thinking along the lines of self-righteous disgust here. For me, it adds some interest to have this guy reacting to another character.

# ANNOYED Flies are attracted
to the stench and begin to circle not only around the sandwich, but around Joey's head as well. What's more annoying than flies buzzing around your head?

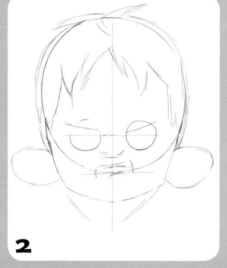 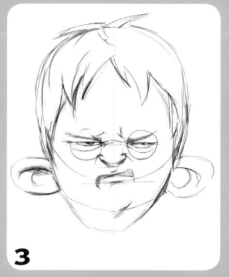

**1**

**2**

**3**

## 1 Draw the Basic Structure
Draw the head structure. You've probably noticed that I've been erasing the jaw line in my final drawing, leaving only the chin. I do this not because Joey is fat, but because he has one of those youthful, almost nonexistent jaw lines. Also, it makes him look more lurpy.

## 2 Rough In the Features
In this expression, his nose is pinched in again, but his nostrils are flared and turned up. His brow is turned down and inward, but not too much or he'll look really angry. His lips come up toward his nose, past where the mouth construction line is. His lower lip is frowning, but the top lip is pulled up with his nostrils.

## 3 Refine and Add Details
Draw his upper eyelids as straight lines and have the lower lids dip slightly below those lines. Draw a few short upward lines near the inside of the brow lines; these soften the angry look and makes his brow look more frustrated. Draw bags under his eyes that come from nostril flare and his furrowed brow. Tilt his upper lip to one side and make sure the ends of his upper lip point down.

## 4 Clean Up
Finish by inking over your pencil lines. Try varying your line widths, making thicker lines where shadows would be. After the ink dries, erase your pencil lines.

## 5 Good-for-Nothing...
If you haven't already colored this picture, go ahead and do it now.

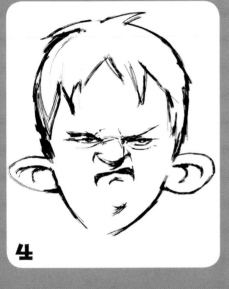

4

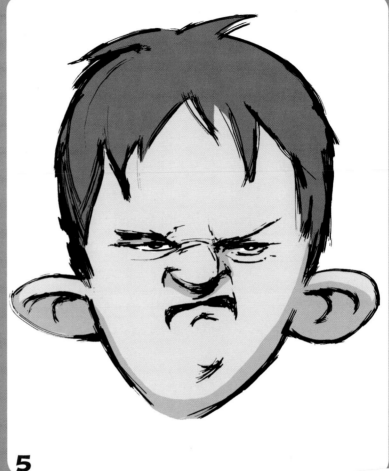

5

## Annoyed Variations

**Gibbs**
The annoyed look of "Please don't talk to me ... you stink"

**Ben**
Nothing can be more annoying than finding out the home you're trying to break into belongs to the chief of police.

**Brandon**
An annoyed woman is so much more interesting than an annoyed man. Maybe it's because I've seen the look from my wife so much, when I'm trying to be clever. There's just something so awesomely condescending about it.

# HOPELESS

The flies have made Joey . . . well, miserable. So now all he can do is stare blankly at this sandwich, which could have been made with ham and cheese, and would have been sitting happily in his stomach. Now, he's hungry and surrounded by flies. Life seems hopeless.

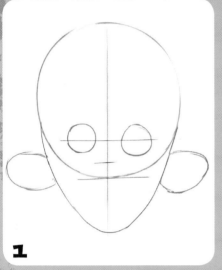

**1**

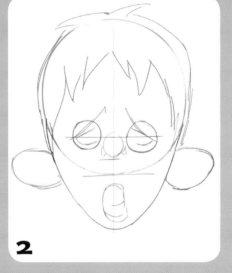

**2**

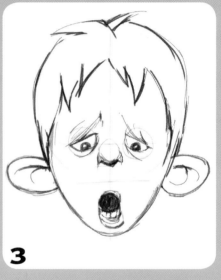

**3**

### 1 Draw the Basic Structure
I went ahead and threw the jaw line down where I thought it might be for this expression.

### 2 Rough In the Features
His nose is pulled up slightly, but his nostrils stay anchored and flared. His brow pinches in and turns up, but not to the extreme that the stinky and disgusted expressions did. His eyes stay open, but add diagonal lines loping up toward the chin for the upper eyelids and drooped, slightly pulled-up lines for the lower eyelids. For the mouth, draw a bean shape down near his chin. Add a horizontal line below the midpoint of the mouth for his exposed lower teeth.

### 3 Refine and Add Details
Draw bags beneath his eyes and show some gums beneath his teeth. Individualize his teeth and define his upper and lower lips. Hopeless eyes often look best when they are looking down; it adds that despairing look.

### 4 Clean Up
Ink over your pencil lines. If you mess up, it's OK. Drawing is fun, so start over.

### 5 Another Lunch Down the Drain
Finish with a splash of vibrant color.

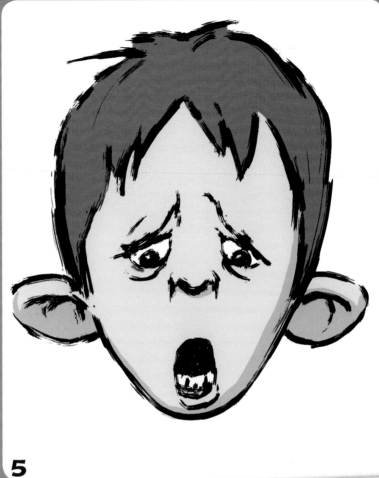

4

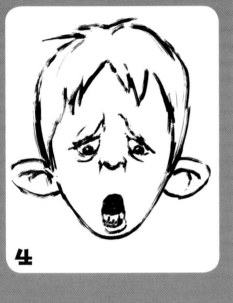

5

## Hopeless Variations

**Ben**
I liked the contrast here of using a buff Roman soldier who is usually very stern for my expression of **hopeless**.

**Brandon**
**Hopeless** is kind of like **sad**, but more resigned. The hair helps to sell it.

**Gibbs**
His stock just dropped 78 percent, and he has nothing left to live for.

# The Hobo

In this scenario, Ben will describe the dynamic facial expressions for crazy, yummy, drunk and hung-over, as shown through the daily life of our hobo, Stinky Joe. Warning! Booze will severely handicap your drawing abilities, especially when it comes to detail. Now, lets have some sober fun!

## ARTIST'S NOTE

While working on the expression for **crazy**, I realized that, without knowing it, I have actually spent several hours in front of my own mirror, in between the usual brushing of teeth and combing of hair, perfecting this very expression. It usually would accompany the words, "Whatayer lookin' at?!"

I did, however, encounter some difficulty in creating the other expressions for this demo. I was even tempted to pull out my camera one day as I was leaving the studio. I passed by a homeless man going through our dumpster. I wanted to say, "Hey, can you act drunk, or hung-over?"

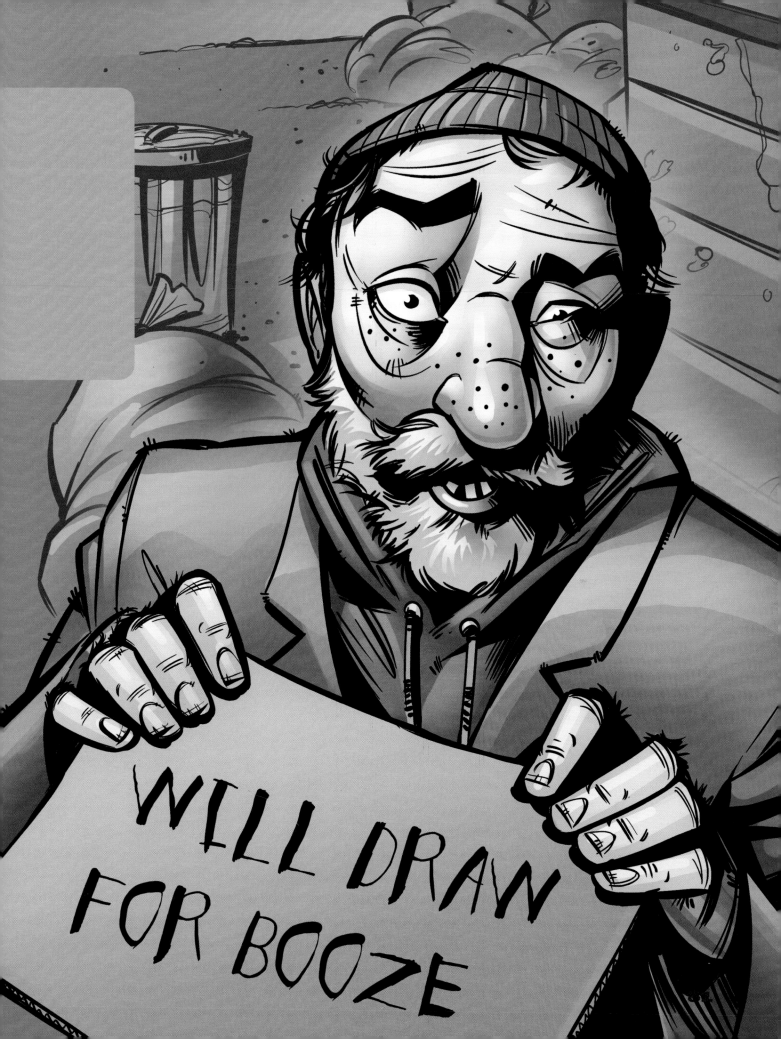

# CRAZY

Stinky Joe is a crazy hobo with a weathered face, deep wrinkles, a large pockmarked nose and greasy, ratty hair. He's always muttering something under his breath about UFOs and additives in cold cereal as he stands there with his cardboard sign waiting for his next big break. Follow along as I show you the classic hobo look for CRAZY. His forehead and eyebrows are twisted in confusion, while his eyes suggest his distorted view.

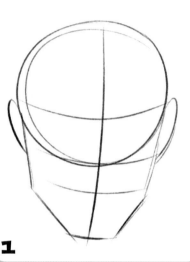

**1**

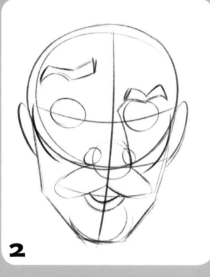

**2**

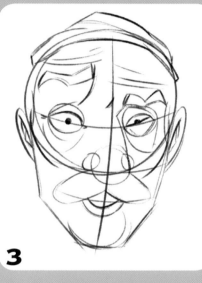

**3**

### 1 Draw the Basic Head Structure

Draw a circle for the cranium and a U-shaped jaw with the sides angled to the chin. Block in the ears using thin ovals. Include the construction lines for the face. Notice that the centerline is slightly curved and off center, and that the construction lines are curved down. This will make the head more dynamic.

### 2 Rough In the Features

Draw the nose using one large circle and two smaller ones. Draw the bridge of the nose with a single line. Draw two circles for the eyes. Then draw two slightly tilted ovals for the mustache. Below that draw three half-circles; two smaller ones for the mouth and one large one for the chin. Indicate cheekbones by drawing two half moons on either side of the head. Draw the eyebrows using long rectangles formed into S-shapes with one higher than the other.

### 3 Refine the Features

Begin adding expression by drawing one eye closed more than the other. Include the pupils. Draw lines for the wrinkles on the forehead and bags under the eyes. Complete the inside of the ears by drawing a few vertical lines. Draw the beanie cap, using sweeping lines for the folds.

### 4 Add Details

Now, erase your construction lines and add detail for the hair, more small wrinkles, dots for the nose and cheeks, and ribbed lines for the beanie cap. Draw three gapped teeth, then darken the eyebrows, mouth, and eyelashes. Add shading under the cheekbones and define the bridge of the nose by adding a bump.

### 5 Clean Up

Clean up the drawing by inking your lines. Add shadows by filling in the right side of the face, around the eyes, and under the nose. Let the ink dry, then erase the pencil lines.

**6 Pretty Much Insane**
I gave Stinky Joe a dirty brown-gray beard and extra-reddened lips and ears to lend this character the general air of unsavory craziness. Deep shadows suggest that he is emerging from a dark alley.

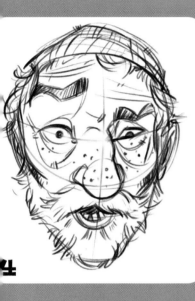

4

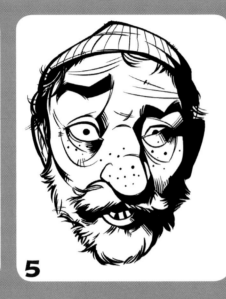

5

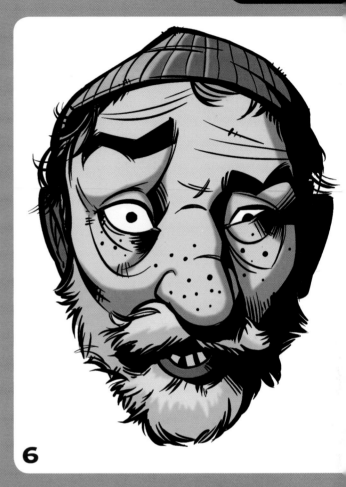

6

## Crazy Variations

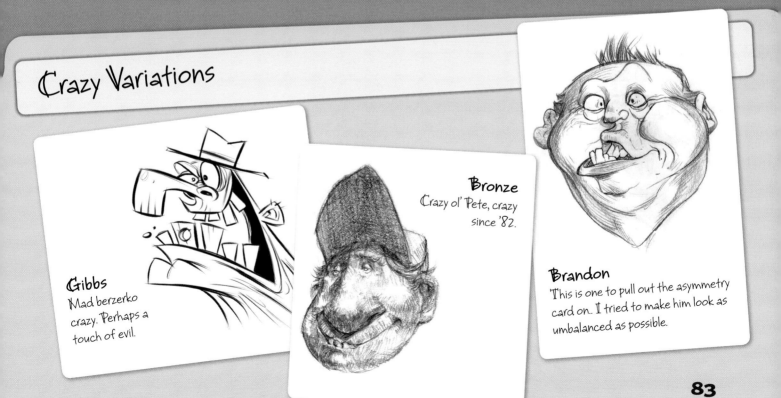

**Gibbs**
Mad berzerko crazy. Perhaps a touch of evil.

**Bronze**
Crazy ol' Pete, crazy since '82.

**Brandon**
This is one to pull out the asymmetry card on.. I tried to make him look as umbalanced as possible.

# YUMMY

What luck! After rummaging through some trash, Stinky Joe finds a bottle of liquor and spends several minutes savoring the thought of pouring it down his gullet. His tongue licks his lips while his wide eyes stare in amazement.

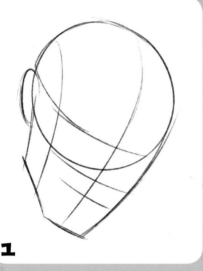

**1**

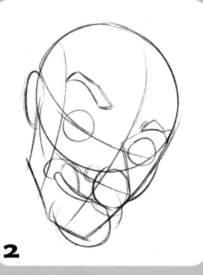

**2**

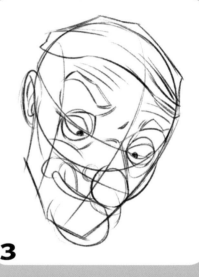

**3**

### 1 Draw the Basic Structure
Draw the basic head structure as for the previous demonstration, but this time rotate and tilt the head for a lower three-quarters view.

### 2 Block In the Features
Block in the basic shapes of the face. Draw the tongue using a half-circle coming up from the bottom lip. Draw the mouth closed and wider than in the previous demo. Draw a circle for the chin sticking out from the structure. Make sure your shapes correspond to the angle of the construction lines.

### 3 Add Rough, Expressive Features
Begin adding expression by drawing in the shape of the eyes with dots for the pupils. Draw lines for the wrinkles on the forehead and bags under the eyes. Draw a line on the cheek that cuts off the lower bag under his right eye. Complete the inside of the ear by drawing a few vertical lines. Draw in the beanie cap and use sweeping lines for the folds.

### 4 Add Details
Now add the detail of hair, more smaller wrinkles, dots for the nose and cheeks, and ribbed lines for the beanie cap. Darken in the eyebrows, mouth, eyelashes and lines around the tongue. Add shading under the cheekbone and nose, then define the bridge of the nose by adding a bump.

### 5 Clean Up
Clean up the drawing by inking your lines. Add shadows by filling in the right side of the face, around the eyes, and under the nose. Let the ink dry, then erase the pencil lines.

### 6 Mmm! My Favorite!
For these demos we have kept the coloring fairly simple, emphasizing highlights and shadows. For your own drawing, try playing around with some other lighting and color combinations.

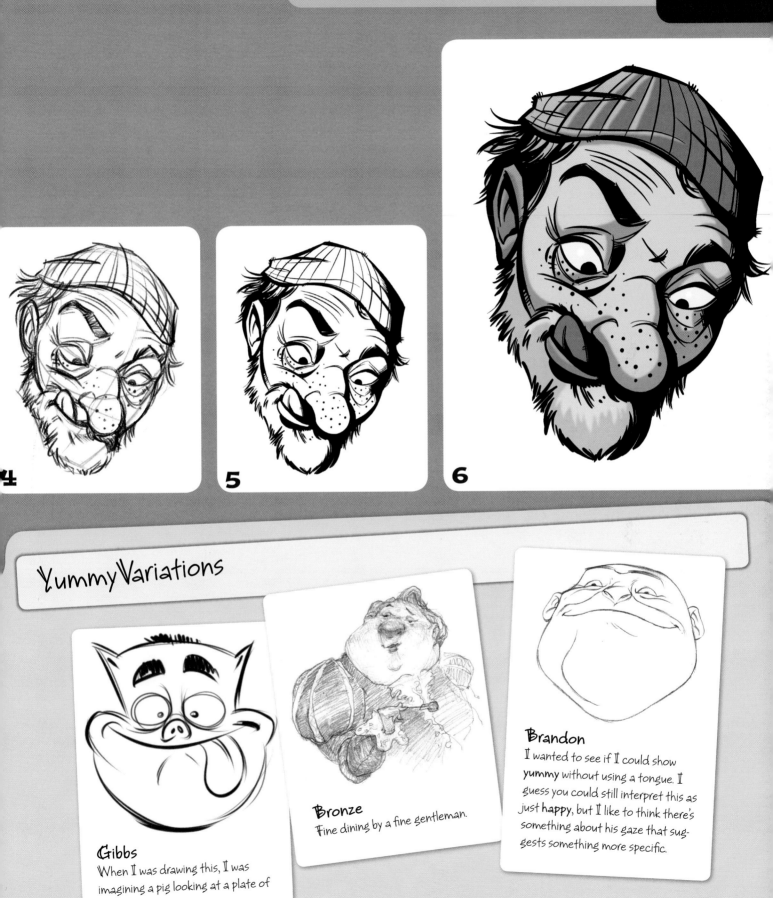

**4**

**5**

**6**

## Yummy Variations

**Gibbs**
When I was drawing this, I was imagining a pig looking at a plate of pork chops.

**Bronze**
Fine dining by a fine gentleman.

**Brandon**
I wanted to see if I could show **yummy** without using a tongue. I guess you could still interpret this as just **happy**, but I like to think there's something about his gaze that suggests something more specific.

# DRUNK

Having downed a fifth of gin, Stinky Joe is now drunk off his rocker and pestering the pigeons as he stumbles along the alleyway he calls home. His eyelids are heavy, covering glossed-over eyes. His smile lifts the bags underneath them.

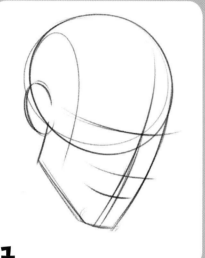

**1**

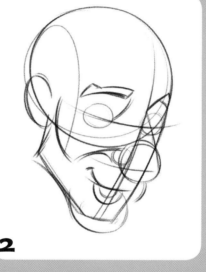

**2**

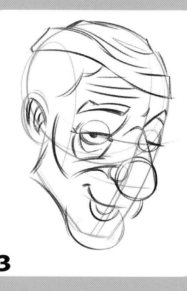

**3**

### 1 Draw the Basic Structure
Draw the basic head structure, tilting it down again, but this time rotating it even more.

### 2 Block In the Basic Shapes
Block in the basic shapes of the face. Draw the mustache using curved lines for the top and side. Draw a full circle for the right eye even though most of it will be hidden. Draw the mouth gaping open using two half-circles. Draw another circle sticking out for the chin. Make sure your shapes correspond to the angle of the construction lines.

### 3 Refine the Features
Begin adding expression by drawing the shape of the eyes and dots for the pupils. Draw lines for the wrinkles on the forehead and bags under the eyes. Draw a line on the cheek that cuts off the lower bag under his right eye. Draw a curved line on the left corner of the mouth to show his smile. Complete the inside of the ear by drawing a few vertical lines. Draw the beanie cap using sweeping lines for the folds.

### 4 Add Detail and Refine
Add details for the hair, more small wrinkles, dots for the nose and cheeks, and ribbed lines for the beanie cap. Draw three gapped teeth, then darken the eyebrows, mouth and top eyelashes. Add shading under the cheekbone and nose, then define the bridge of the nose by adding a bump.

### 5 Clean Up
Clean up the drawing by inking your lines. Add shadows by filling in the right side of the face, around the eyes, and under the nose. Add some extra lines on the top eyelids. Let the ink dry, then erase the pencil lines.

### 6 One Too Many
Now that you've nailed the expression, complete your masterpiece with some color.

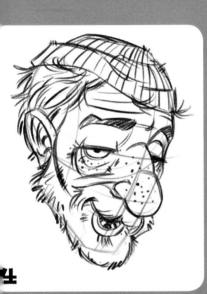

4

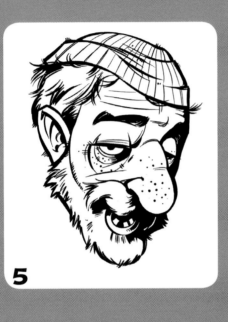

5

6

## Drunk Variations

### Brandon

I played around with this one a little bit before it felt totally right. The features that seemed to make it work were the underbite and the curled up smile. The cross-eyes also help to sell it.

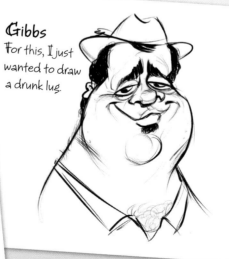

### Gibbs

For this, I just wanted to draw a drunk lug.

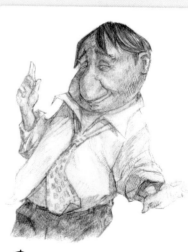

### Bronze

Drunk fun! No, wait—it's not fun.

# HUNG-OVER

After a night of heavy drinking, Stinky Joe is now in the hung-over stage. He leans against the brick wall, his ears ringing ever since he opened his eyes. His face is long and his skin hangs loose on his skull. His eyelids are heavy and he's lost the strength to close his mouth.

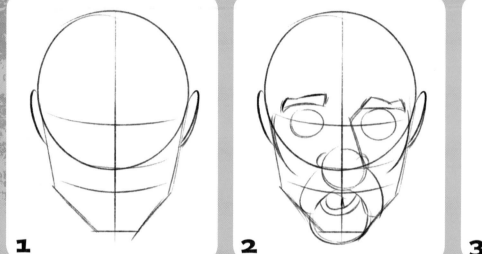

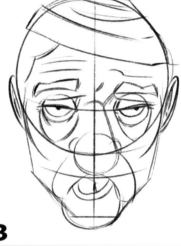

## 1 Draw the Basic Structure
Draw a circle for the cranium and a U-shaped jaw with the sides angled toward the chin. Block in the ears using thin ovals. Include the construction lines for the face. Notice that the construction lines are slightly curved down.

## 2 Rough In the Features
Draw the nose using one large circle and two smaller ones. Draw the bridge of the nose with a single line. Draw two circles for the eyes. Add curved lines on either side of the nose for the mustache. Below that, draw three half-circles: two small ones for the mouth and one large one for the chin. Indicate cheekbones by drawing two half-moons on either side of the head. Draw the eyebrows using long rectangles with dents on the top.

## 3 Refine the Features
Begin adding expression by drawing heavy eyelids and offset pupils. Draw lines for the wrinkles on the forehead and oval bags under the eyes. Complete the inside of the ears by drawing a few vertical lines. Draw the beanie cap using sweeping lines for the folds.

## 4 Add Details
Add details for the hair, more small wrinkles, dots for the nose and cheeks, and ribbed lines for the beanie cap. Draw three gapped teeth, then darken the eyebrows, mouth and eyelashes. Add shading under the cheekbones and define the bridge of the nose by adding a bump.

## 5 Clean Up
Clean up the drawing by inking your lines. Add shadows by filling in the right side of the face, around the eyes, and under the nose. Let the ink dry, then erase the pencil lines.

## 6 Rough Morning
Congratulations on getting this far! Add mood to the character by rendering your drawing color. I used a computer and software that allows me to color underneath my ink work, but you could use colored pencils, watercolors, markers or whatever. Just color away!

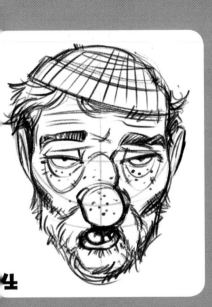

**4**

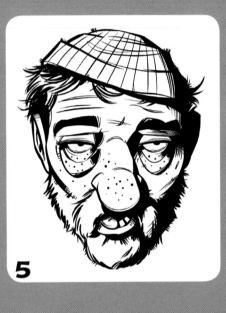

**5**

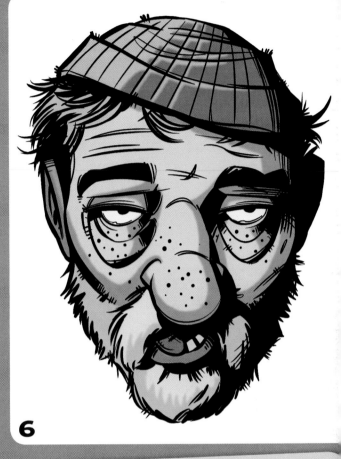

**6**

## Hung-Over Variations

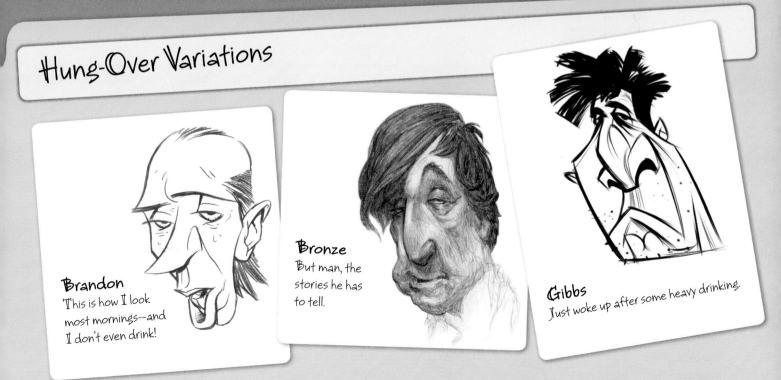

**Brandon**
This is how I look most mornings—and I don't even drink!

**Bronze**
But man, the stories he has to tell.

**Gibbs**
Just woke up after some heavy drinking.

# Gina Gets a Lecture

So, like, now Blake is going to draw expressions for, like, a teenage girl.
Gina is an "emo" girl, so emotions are her trademark. She normally
ignores her dad—until he lays down the law.

## ARTIST'S NOTE

Teenage girls present a great opportunity to explore expressions. If you have ever watched a group of girls talking, you know that their faces convey a lot of emotional messages. It's a good thing too, because they're usually not the most verbally coherent people.

When I was in high school, I had a friend I liked to watch when she was on her phone. Even though the other person could not see her, her face still displayed all her emotions. I may not have been able to hear the whole conversation, but I could always tell what was going on.

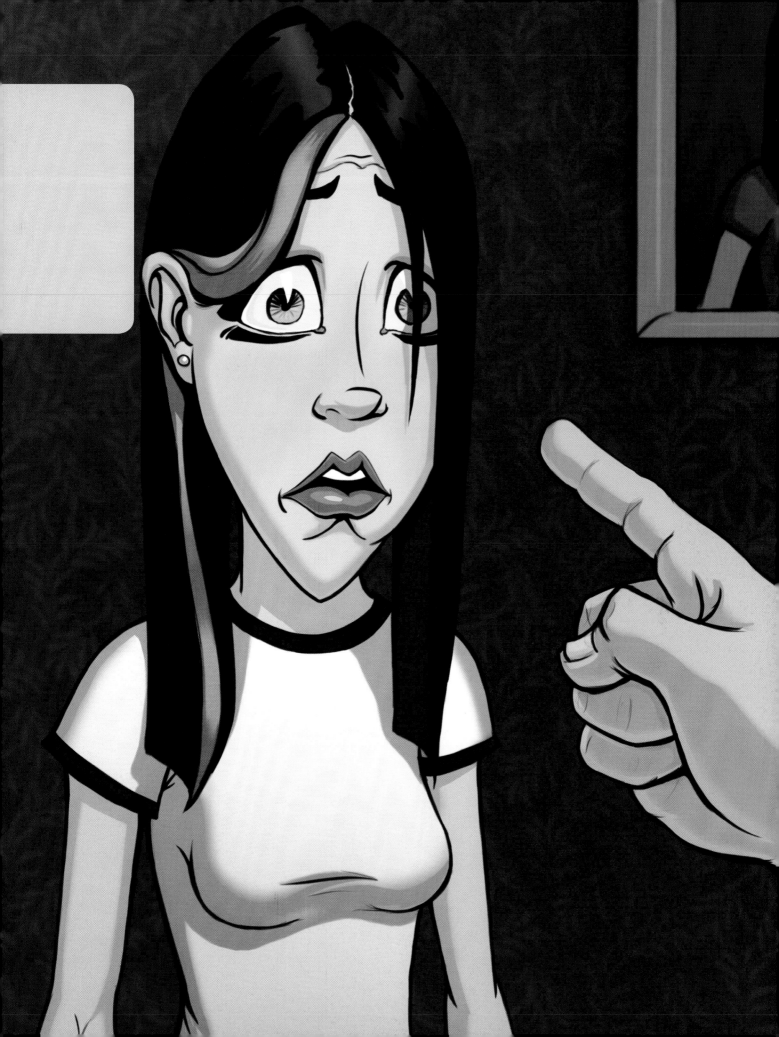

# ROLLING EYES

Dad tells Gina that they need to have a talk. Gina rolls her eyes.

Oh great, another one of Dad's "little talks." Gina thinks that this will be some minor discussion, maybe just a suggestion that she MIGHT want to be home on time. Since she doesn't really know the seriousness of the talk, her expression should be somewhat lighthearted. She's not angry—just inconvenienced. "This had better be quick; I've got some text messages to send."

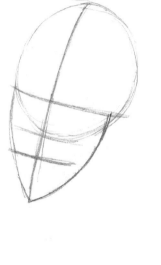

**1**

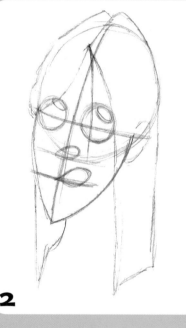

**2**

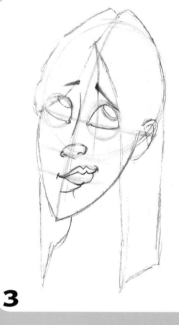

**3**

## 1 Draw the Structure

Draw a circle for the cranium and a pointed U-shape for the jaw line. The centerline will be slightly curved because this is a three-quarters view. Indicate your eye line halfway down the mass of the head. Also draw lines for the general placement of the nose and mouth.

## 2 Rough In the Features

Draw the circles for the eyes. Notice that the irises should be oval-shaped because they are toward the edge of the sphere of the eyes. Her mouth is pushed to the side, which affects the angle of her nose, so you should tilt the oval of the nose. Draw the overall shape of the hair, keeping in mind the way long hair would fall across the face.

## 3 Refine the Features

Because she is looking up, her upper eyelids are fully open and her bottom lids are pulled up. Define the nose and mouth further. It is important to articulate these features correctly to support the expression. After you draw the lips, draw the tension on the muscles around her mouth. Once you add the eyebrows, expression should be apparent.

## 4 Add Details

This stage is important for clarity. Shade in the lighting for the irises and draw the eyelashes. Show how the eyebrows are affecting the shape of the eyes. Add detail to the ear. Add some lines on the right side of the mouth to reinforce the smirk. Indicate the details of the hair.

**5 Clean Up**
Consider your line thickness as you ink. Lines can be thicker in areas of implied shadow and depth, such as the jaw line, under the lips and where the eyes meet the brow. Draw faint indicators of highlights on the lips and eyes. Also, draw a thin line on the tip of the nose to show the contour.

**6 Whatever ...**
The color scheme not only highlights the hair and lips, but also integrates them.

4

5

6

## Rolling Eyes Variations

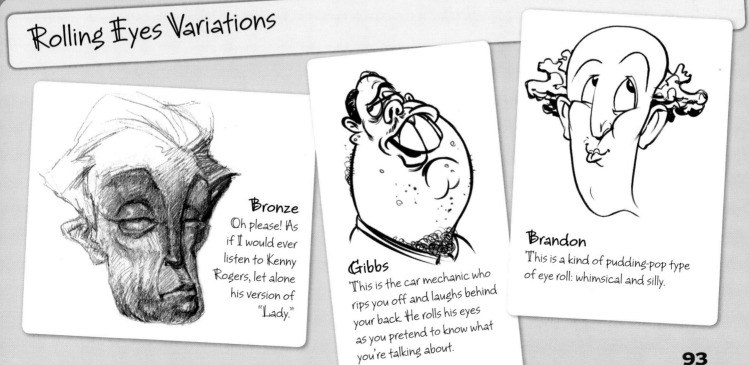

**Bronze**
Oh please! As if I would ever listen to Kenny Rogers, let alone his version of "Lady."

**Gibbs**
This is the car mechanic who rips you off and laughs behind your back. He rolls his eyes as you pretend to know what you're talking about.

**Brandon**
This is a kind of pudding-pop type of eye roll: whimsical and silly.

# CONFUSED
Gina doesn't really know what to think yet. I chose a three-quarters view for this drawing to show that she is ready to walk away at any second because, at first, she doesn't think her father has anything important to say. Her eyes, however, are drawn to him as she realizes that he is serious, and that she'd better pay attention.

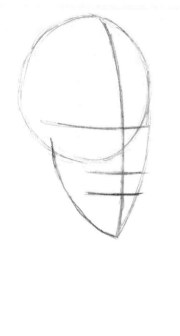

**1**

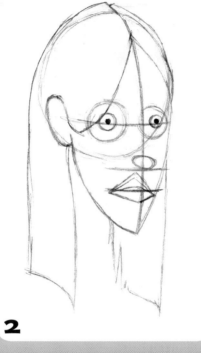

**2**

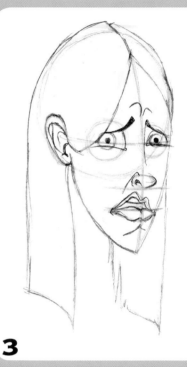

**3**

### 1 Draw the Structure
Start with a circle for the cranium. Draw the pointed U-shape for the jaw, remembering that it must be asymmetrical for the three-quarters view. The centerline should curve to follow the form of the face. Draw the guidelines for the eyes, nose and mouth.

### 2 Rough In the Features
Draw circles for the eyeballs, irises and pupils. Keep in mind that the eyes sit behind the face, so the far eye will overlap the centerline. Indicate where the hair and ear will be. Draw a simplified shape for the mouth and lips. This will be a sneer, so draw the shapes accordingly. Draw a slight tilt to the oval of the nose to show how it is affected by the mouth.

### 3 Refine the Expression
This stage is where the expression should really become apparent. Draw the bottom eyelids high up on the irises to show a confused, suspicious stare. In contrast, the upper eyelid should be fully open to show the shock of the news rather than suspicion. Draw the upward sweep of the eyebrows and their effect on the forehead. If this were a man, you could really exaggerate the wrinkles of the forehead and brow, but because she is a young woman, the skin on her forehead should appear very smooth and tight. You can develop the sneering expression further with the open mouth and the wrinkle on the side of the nose along with a flared nostril.

### 4 Add Shading and Details
Shade some of the areas to see if the expression is reading well. You may need to go over the cheek and jaw line to add some fullness to the face. Notice the way the chin breaks from the line of the cheek. Add details to the ear and hair. You can also erase the guidelines, as they may get in the way during the inking stage.

**5 Clean Up and Ink**
As always during the inking stage, remember to vary the line thickness. A common place to add a thin line is on the upper cheek, near the eye. This implies a highlight and gives form to that part of the face. Break up the large shape of the hair with a separated strand.

**6 Um ...**
Her brightly colored eyes help to accentuate the expression.

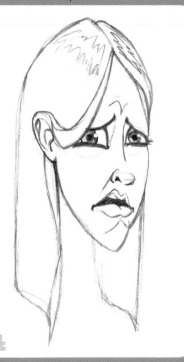

**5**

**6**

## Confused Variations

**Bronze**
"I never seen a chicken do that."

**Gibbs**
This is the expression I get a lot when someone has no idea what I'm talking about, but in my own head I make sense.

**Ben**
What do you mean my hairstyle was never in?

# DUMBFOUNDED

Not only is he taking the car away, but she's grounded! "What the @%*! There is, like, no way!" Gina is dumbfounded to realize that she is finally getting punished for her behavior. Remember, she is a teenager and has gotten her way most of the time, but now her usually lenient parents are laying down the law. Gina is caught off guard. Since there hasn't been time for her to build up a lot of emotion, her reaction will show mostly in her eyes and eyebrows. Wide-open eyes are the most important aspect of this expression. Her mouth won't be too extreme. The corners of the mouth show that she has the slack jaw of someone who is surprised, not yelling or laughing.

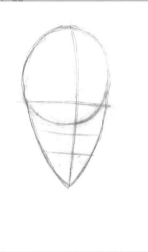

1

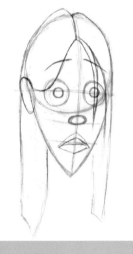

2

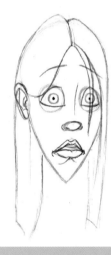

3

## 1 Draw the Basic Structure

Draw the circle for the cranium as usual. In this drawing her mouth will be open a bit, so the jaw line needs to extend down farther. Also, remember to make it more of a V-shape; that is a defining feature of this character. This is not a full three-quarters view, so be sure the centerline corresponds to the curve of the form.

## 3 Refine the Features

Add the eyelids, making sure that they don't overlap the irises. Add nostrils and a thin line to indicate the bridge of the nose. Because she is a young girl, you don't want to over-define the nose. Describe the contours of the lips and indicate the fleshy muscles below them; this is an important feature to this character. Define the shapes of the ear.

## 2 Rough In the Features

This is where you establish the structure for the expression. Draw the mouth open and somewhat pouty. Draw circles for the eyes. Place the irises carefully because they have a dramatic impact on the expression. After you indicate where the eyebrows will be, you should really get a sense of how the emotion is coming across. If the expression doesn't work, revise the drawing.

## 4 Add Details

This is where it all comes together. Darken the inside of the mouth and give her thick eyeliner. You may need to add some bulk to her cheeks to help show that her mouth is open and relaxed. Having the right cheek overlap the chin adds bulk and reinforces the expression.

## 5 Clean Up

Use ink lines to add drama. Render the pupils quite small and draw thin radial lines in the irises to create the effect of light-colored eyes. Make thick lines under the lips and nose. Add a thick line under the light streak of hair to suggest a shadow. Add a thin line in the light streak of hair to break it up and make it look more like hair than a thick cord.

## 6 My Life Is Over

The intensity of the highlights can change the perception of the texture. The highlights in her hair are more subdued than the highlights on the eyes and lips.

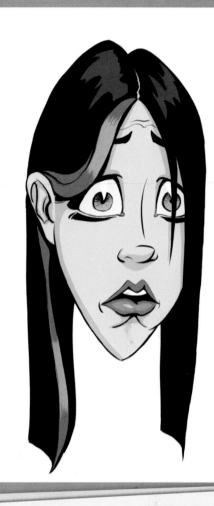

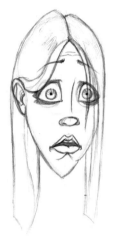

**4**

**5**

**6**

## Dumbfounded Variations

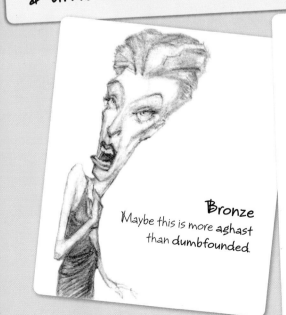

**Bronze**
Maybe this is more aghast than dumbfounded.

**Gibbs**
She's just been told that the oysters she's eating have expired.

**Brandon**
A little bit of righteous indignation.

# HOSTILE

To top it all off, she's forbidden to see Brad ever again.

Dang, Gina! Well, that's it. She's about to storm off to pout in her room. She'll be giving her dad the silent treatment for weeks—but before she goes, she gives him an intense glare.

As with most expressions, the eyes are crucial to the portrayal of hostility. All of the flesh surrounding the eyes is brought into play. The eyebrows come down, the cheeks come up and the eyelids nearly close. Her mouth will be a mixture of a sneer and a pout. Gina's trademark muscles below her mouth will be very prominent here.

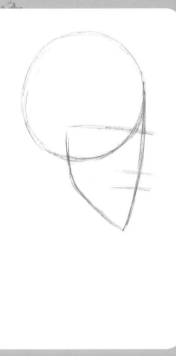

**1**

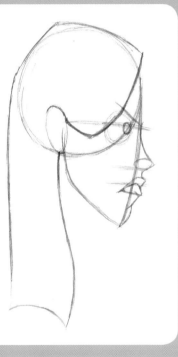

**2**

**3**

## 1 Draw the Structure

Draw a circle for the cranium. Because this is a profile view, the bottom part of the face will be a bit different. The line for the front of the face curves in slightly toward the chin. The jaw line angles up, then curves, ending halfway into the cranium. Draw the eye line halfway from the top of the head to the chin. The nose is a little less than halfway down from the eye line. The mouth is a third of that remaining distance.

## 2 Rough In the Features

Indicate the end of the nose with an oval that extends beyond the face line. Indicate the lips, then draw the profile of the nose, lips and chin. Draw a circle for the eye and an oval for the iris. The eyes are not flush with the face, but are set in. Indicate the shape of the hair. By angling the eyebrow down, partially obscuring the eye, you suggest hostility.

## 3 Refine the Features

Refine the angry sneer of the mouth and add a slightly flared nostril. In this expression, her eyes act almost like a black hole: all the surrounding features are pulled toward them. Not only does the eyebrow come down over the eye, but the cheek rises and pushes the lower lid up. This keeps the eye open just enough for the pupil to see out.

## 4 Add Details

Erase the construction lines that established the face. Add a protrusion where the eyebrows have pushed out a mass of skin above the eyes. These exaggerated eyebrows cast a shadow, so darken the area around the eyes. Draw the last details of the ears and hair. Look away from the drawing for a while, then quickly look back. If the expression doesn't read *hostile* the instant you look back, you need to revise.

## 5 Clean Up

As you ink your drawing, emphasize the thickness under the jaw and the thinness of the lines on the front of the face. Ink the hair so that it looks like she has shiny jet-black hair with a light streak at the front.

## 6 War!

Add color as for the previous demos.

**4**

**5**

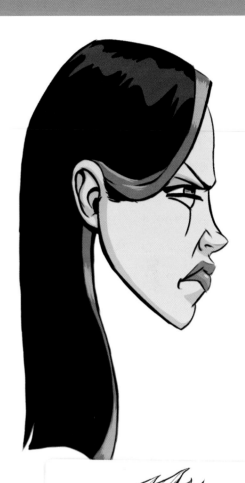

**6**

# Hostile Variations

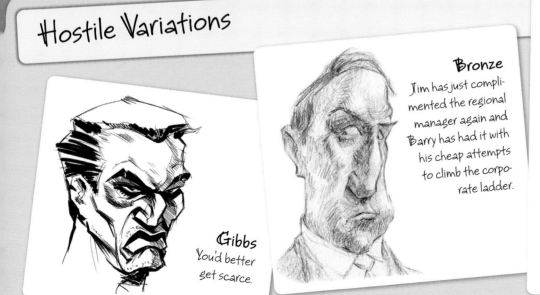

**Gibbs**
You'd better get scarce.

**Bronze**
Jim has just complimented the regional manager again and Barry has had it with his cheap attempts to climb the corporate ladder.

**Brandon**
To me, hostility is a very focused emotion. I wanted to show that this guy's hostility is directed someplace specific, and is very intense.

# Betsy the Farm Girl

Betsy is not your typical airhead: she knows how to get exactly what she wants. This farm girl has an arsenal of deadly facial expressions that could break the willpower of any man. In this scenario, Ben will demonstrate how to make her look sassy, flirty, happily surprised and pouty. Knowing what goes into such expressions will increase your confidence—and maybe prepare you to withstand such tactics from your own significant other!

## ARTIST'S NOTE

This scenario was supposed to be about an airhead girl and her not-so-smart boyfriend. I went to work sketching some character ideas, starting with a stereotypical hot farm girl. I tried other ideas but kept coming back to this one. As I began sketching expressions, Betsy began to evolve from an airhead worthy of all blonde jokes to a foxy lady who knows how to use her beauty to get her way—even if it means playing the airhead.

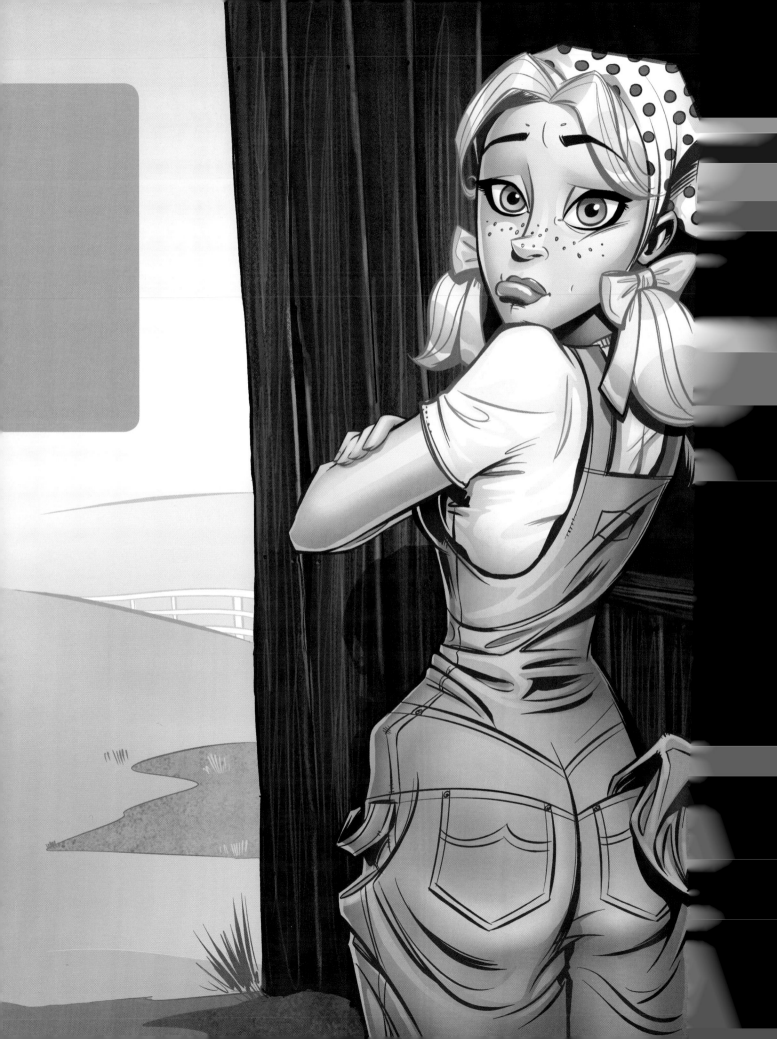

# SASSY

Betsy's boyfriend comes over after a long night on the town with his buddies. One look at Betsy's face tells him he's in big trouble!

I painfully recall an experience of my own when I came home to find the same look on my wife's face. She said, "Who's this Tammy girl?!" I had no idea—honest!

In this demo I will show you how to throw some sass into your character to help her get whatever she wants. The sassy look has one eyebrow raised while the other is lowered. The nose is slightly crinkled and pulled to one side with the mouth; the face and jaw are twisted the same way. Usually this expression is followed by some head wagging and the index finger in the air. She's getting impatient, so let's get to it!

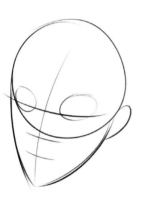

**1**

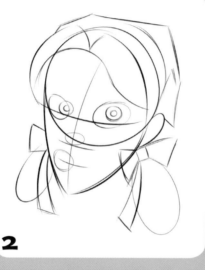

**2**

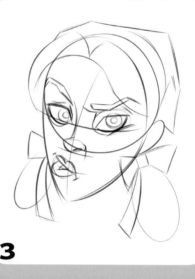

**3**

**1 Draw the Basic Structure**
Draw a circle for the cranium and a pointed, U-shaped jaw. Block in one ear using a half-moon shape and the eyes using angled ovals. Add construction lines for the face. Notice that the head is tilted down and to the left. This will be the basic head structure for the following demos.

**2 Block In the Basic Features**
Use basic shapes for the ponytails, kerchief, bangs and bows. Use circles to plot the placement of the mouth, nose and eyes.

**3 Refine the Features**
Draw the eyebrows, making one lower than the other. Refine the shape of the eyes, making the outer point much higher than the inner. Complete the nose by drawing a tapered line vertically from the tip to the left eyebrow, a flat circle for the nostril, and curved lines for the bottom of the nose. Draw the mouth pursed, slightly open, and off to the left side.

**4 Add Details**
Darken the eyelashes, eyebrows and pupils. Complete the ponytails by flipping the hair at the tips with sweeping lines. Do the same for the bangs. Draw in the pattern of the kerchief and add freckles to the nose and cheeks. Finish the ear. Then add a slight wrinkle to the forehead using a small pencil mark.

**5 Clean Up**
Ink over the pencil lines using sweeping lines that vary in thickness. Add shadows to the fold of the kerchief and under the nose and bangs. Let the ink dry, then erase the pencil lines.

**6 Sassy ... and Freckly**
When coloring the hair, remember that blonde doesn't mean yellow; blonde is more like a warm tan color. Sometimes it might be almost the same color as the skin.

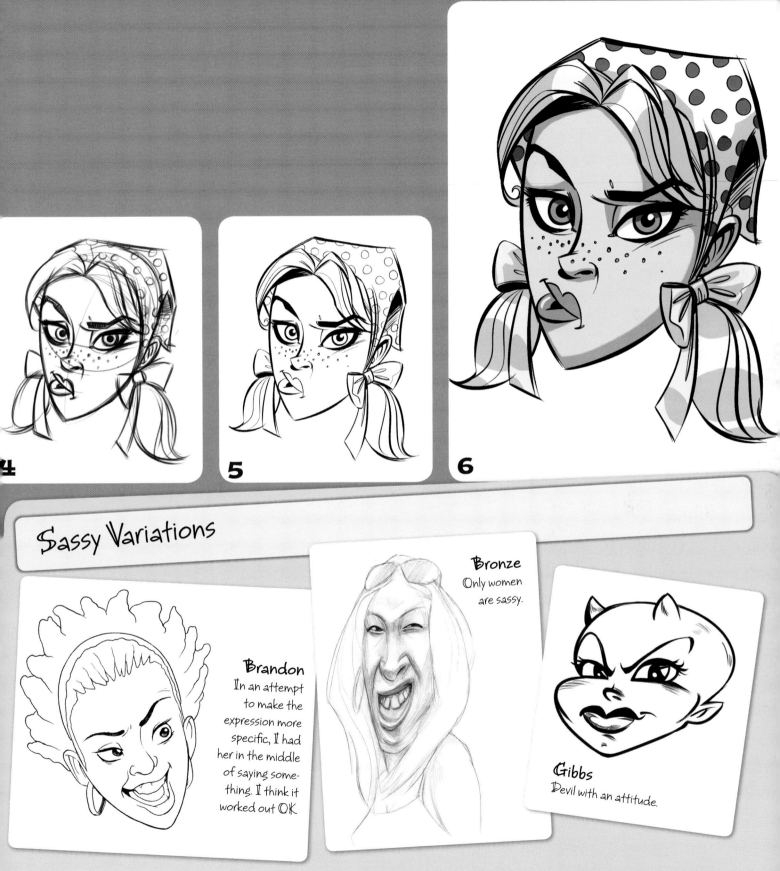

**4**

**5**

**6**

## Sassy Variations

**Brandon**
In an attempt to make the expression more specific, I had her in the middle of saying something. I think it worked out OK

**Bronze**
Only women are sassy.

**Gibbs**
Devil with an attitude.

# FLIRTY

Betsy notices that her boyfriend has something hidden behind his back. She tries to get him to show her what it is by turning on the charm.

The flirty expression can be really subtle, so if a hot girl looks at you like this, pay attention (and don't forget your name or reasoning power!). Just in case you don't know what you're looking for, flirty usually has one eyebrow slightly raised, dreamy eyes and a soft, sly smile in one corner of the mouth. If you're on the other end of this expression and still not getting the point, she might try biting an earlobe and whispering sweet nothings into your ear. Take a minute to regroup, then start drawing!

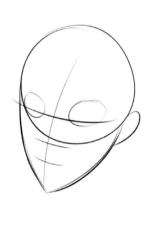

1

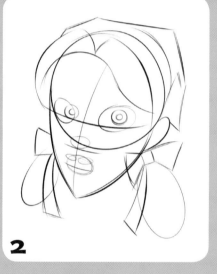

2

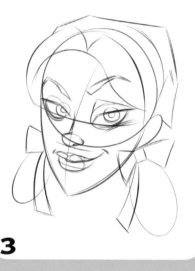

3

## 1 Draw the Basic Structure
Draw the basic head structure as for the last demo, remembering to point the chin. Don't forget the ear and place those eyes along the construction lines as shown here.

## 2 Block In the Basic Shapes
Draw basic shapes for the pony tails, kerchief, bangs and bows. Use circles to plot the placement of the mouth, lips, nose and eyes.

## 3 Refine the Features
Draw the eyebrows, arching one higher than the other. Refine the shape of the eyes, making the outer point much higher than the inner. Complete the nose. Draw the mouth closed and slightly curved upward, with one corner pulled more to the upper right for the sly smile.

## 4 Add Details
Darken the eyelashes, eyebrows and pupils. This helps to see what the finished image will look like. Use those sweeping arm movements to complete the ponytails and bangs. Fill in the kerchief with a dotted pattern. Add freckles to the nose and cheeks, and then finish the ear.

## 5 Clean Up
Ink the drawing using lines that vary in thickness. Decide which direction you want the light to come from and fill in the shadow areas. Let the ink dry, then erase those pesky pencil marks.

## 6 Hubba Hubba
Complete your drawing with some color. I used a computer, but you can achieve the same effect with a set of markers or your favorite medium. Whatever you use, it takes a lot of practice to get a professional look.

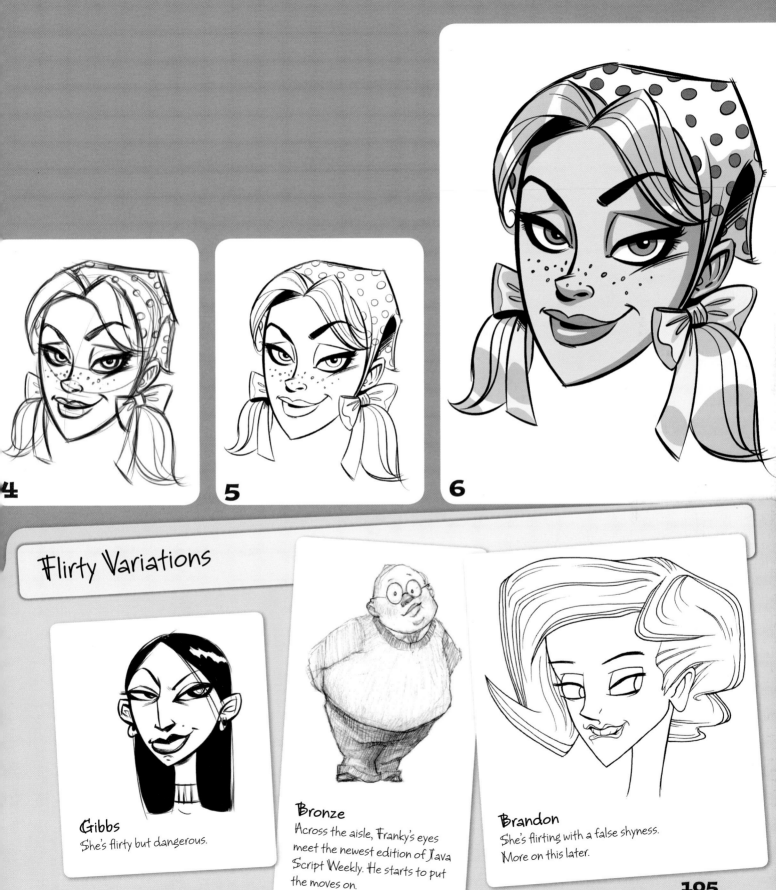

**4**

**5**

**6**

## Flirty Variations

**Gibbs**
She's flirty but dangerous.

**Bronze**
Across the aisle, Franky's eyes meet the newest edition of Java Script Weekly. He starts to put the moves on.

**Brandon**
She's flirting with a false shyness. More on this later.

**105**

# HAPPILY SURPRISED

"It's a new puppy!" Betsy squeals in surprise. "How did you know I love puppies?!"

Actually, the puppy isn't for Betsy: it's really her boyfriend's new hunting dog. But she doesn't find that out until our next demo.

For this facial expression, I made several grown men act it out, squealing, in our studio before I felt confident enough to put pencil to paper. After a few revisions, I discovered that there is a fine line between UNPLEASANTLY SURPRISED and HAPPILY SURPRISED. With a happy surprise, the eyebrows are raised high on the face, the eyes are wide open and the mouth is an O-shape with the corners turned up. Let's draw this one—but before we start, try acting this out with all of your friends!

**1**

**2**

**3**

### 1 Draw the Basic Structure
You know the drill here. Get your basic shapes down and don't forget those construction lines. I know what you're thinking, but even a seasoned professional still uses these basic building blocks.

### 2 Block In the Features
Plot the placement of the facial features, hair and accessories as you did for the previous demo. But wait! Notice that the pupils of the eyes are a little smaller than normal.

### 3 Refine the Features
Float the eyebrows high on the forehead and draw them a little thinner than usual. Draw the eyes with the outer point much higher than the inner. Add the nose. Draw the mouth open in an O-shape with the corners pulled up.

### 4 Add Details
Complete the ponytails and the bangs. Draw the pattern of the kerchief and add the freckles to the nose and cheeks. Complete the ear.

### 5 Clean Up
Break out that ink well and start cleaning up your beautiful drawing. Remember to use thick and thin strokes, and don't forget your shadows.

### 6 A Puppy ... You Didn't!
Now, finish it off with color. Try adding some white highlights to the lips and eyes for that glossy look.

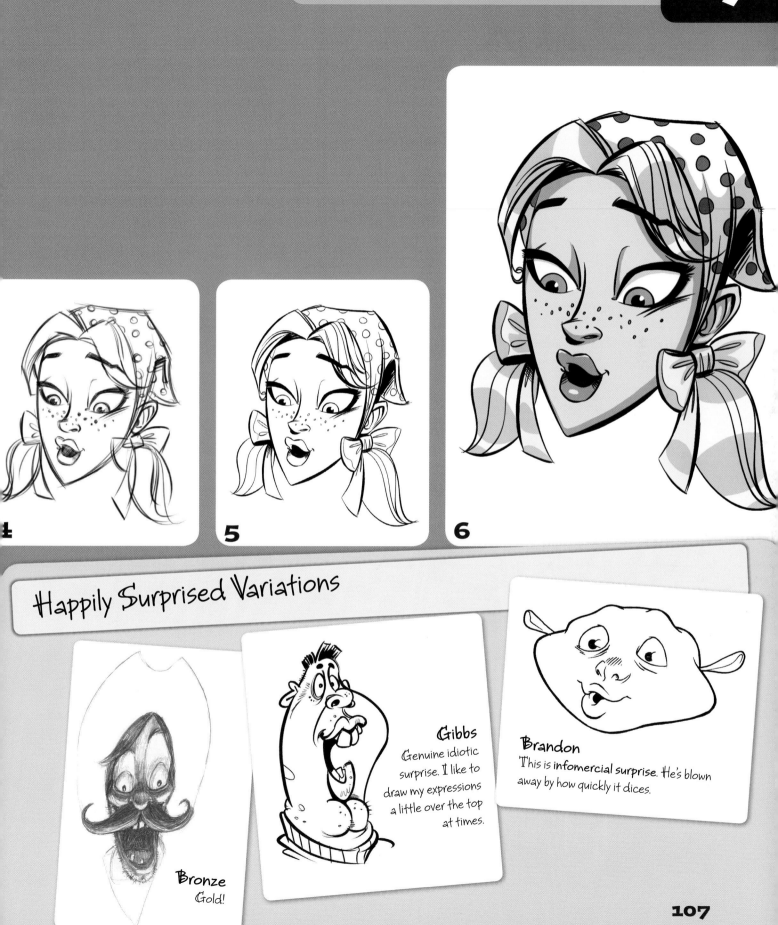

**4**

**5**

**6**

## Happily Surprised Variations

**Bronze**
Gold!

**Gibbs**
Genuine idiotic surprise. I like to draw my expressions a little over the top at times.

**Brandon**
This is infomercial surprise. He's blown away by how quickly it dices.

# POUTY

When Betsy learns the disappointing truth, she turns on her own pouty puppy-dog face. Reluctantly, her boyfriend hands over the puppy, even though he really wants to keep it for himself.

No one can resist a pouty face, especially when it's on our favorite girl. Here are some things to look for in a classic pouty expression: large, glossed-over eyes and pupils, a protruding bottom lip and a furrowed brow. If you ever find yourself on the other end of this expression, quickly avert your eyes and look for an escape!

**1**

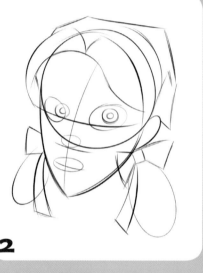

**2**

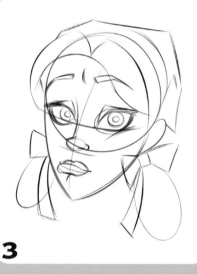

**3**

## 1 Draw the Basic Structure
Nothing new here. By now you must be really good at laying down those construction lines and doing it really quickly.

## 2 Block In the Features
Give yourself some placeholders for the hair, eyes, nose and so forth by using our favorite circle shape. Notice that for this expression, the pupils of the eyes are larger than normal.

## 3 Refine the Features
Draw the eyebrows high and pinched toward the center of the forehead. Draw the outer shape of the eyes much wider than normal. Complete the nose. Draw the bottom lip more pronounced, almost covering the upper lip. Add a pucker line under the bottom lip.

## 4 Add Details
Darken the eyelashes, eyebrows and pupils. Complete the ponytails by flipping the hair at the tips, using sweeping lines. Do the same for the bangs. Draw the pattern of the kerchief and add freckles to the nose and cheeks. Complete the ear.

## 5 Clean Up
Ink over your pencil lines. Add shadows that correspond to your light source. Let the ink dry, then erase the pencil lines.

## 6 Add Color
Add color following your chosen color scheme and you are all done! Now, try applying these principles to one of your own designs.

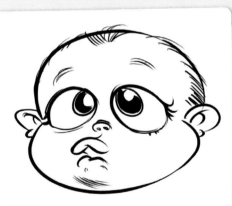

**5**

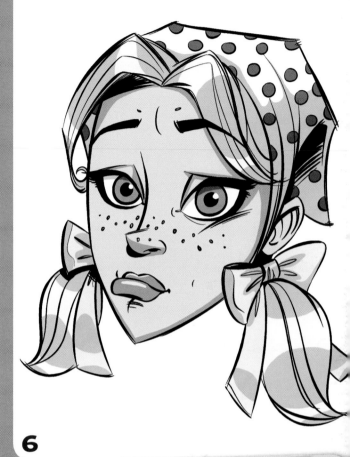

**6**

## Pouty Variations

**Bronze**
B-b-b-but I wanted you to love me. Why won't you love me?

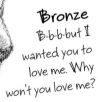

**Gibbs**
This is the look my child gives me when she gets startled. She's six months old.

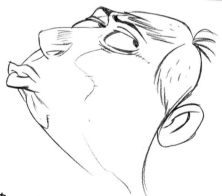

**Brandon**
There's something very entertaining about an adult who doesn't realize that he's acting like a child. At least, that's what my wife tells me.

# The Fight

Finally, a chance to draw what comics are really all about: violence! In this scenario, we're going to follow a no-holds-barred slugfest between Captain Thunder and Serpentra. Brandon will show you how to make Captain Thunder look when he's ready for action, yelling, slugged in the gut, exhausted and cowering. Gibbs will draw Serpentra when she's growling, attacking, electrocuted and gloating.

## Prepare for battle!

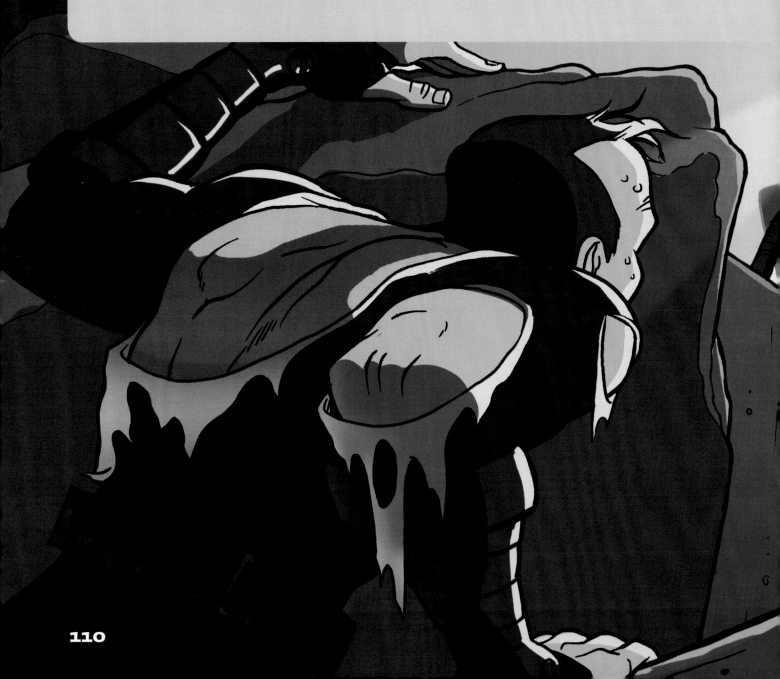

## ARTIST'S NOTE

Gibbs and I are huge superhero geeks. This scenario was, by far, the most fun to work on. The biggest challenge was trying to create two different character designs from two different artists that would look as though they could exist in the same universe. It was also interesting to think about how their reactions to each other affected their expressions.

# READY FOR ACTION Captain

Thunder is a hardened veteran. He knows not to run hot-headed into a brawl. He takes a moment to size up his opponent before jumping into the fray.

The expression here is subtle and contained—but not too subtle, because Captain Thunder is a superhero.

Think about the inner state of the character as he prepares for a fight. He cannot be sure of the outcome, but he doesn't want to show any weakness. There's potential for some pretty complex stuff.

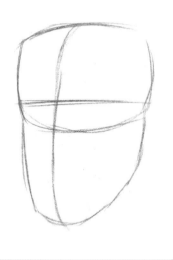

**1**

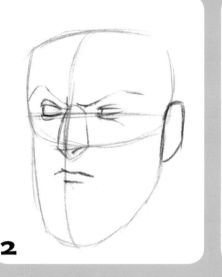

**2**

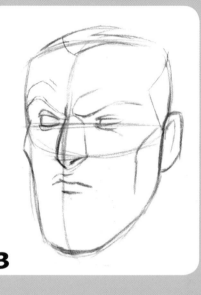

**3**

## 1 Draw the Basic Structure

Start with a pretty standard head shape. Superheroes are not much different in design from generic people; they're just stylized in a few places to make them look more noble and masculine. For this head design, make the chin a bit more prominent than usual and give the cranium a squared, blocky shape to really emphasize his masculinity.

## 2 Block In the Features

Give him tight lips to show the tension in his face, and open one of his eyes to suggest a bit of uncertainty in his glare. Remember to make the eyelids wrap around the eyes.

## 3 Add Secondary Shapes

Sketch in the area of the hair. The hair should just crop into his face from the top of the head and the temples, suggesting a receding hairline. Show how the muscles around his face are affected by the movement of his mouth and eyes. Indicate strong cheekbones on both sides.

## 4 Add Details

Add additional lines to show energy and tension. Thicken the lines under the chin, between the lips, around the eyes, and along the profile of the nose. Indicate the highlights in the hair. He's got shiny, slicked back hair, so a single broad bar will do the trick. Finally, indicate where his mask will sit. The top edge of the mask will follow his eyebrows.

## 5 Clean Up

Ink over the pencil lines. Fill in the hair with black, leaving the white highlight. You can add a few light strokes in the highlight to suggest the direction of the hair. If you're feeling confident, add a few additional lines to indicate tension and describe form.

## 6 "I Don't Like Your Green Face, Serpentra"

I'm imagining that Captain Thunder's face is illuminated by an eerie bluish-green light that makes his skin cooler and grayer than normal.

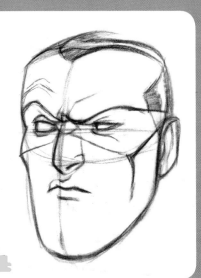

**5**

**6**

## Ready for Action Variations

**Bronze**
He doesn't even blink. He just keeps eyeing the table waiting for someone to make the wrong move.

**Gibbs**
Even an extraterrestrial can be ready for action.

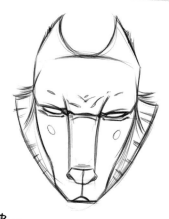

**Ben**
Sliver eyes and a small mouth say "ready for action" to me.

# GROWLING Serpentra

is extremely angry. The mere appearance of her nemesis fills her with disgust. These feelings appear on her face as a hideous growl. Think of a cornered badger trying to escape.

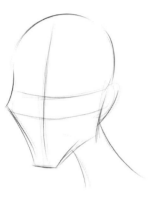

**1**

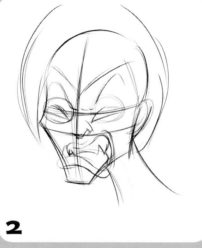

**2**

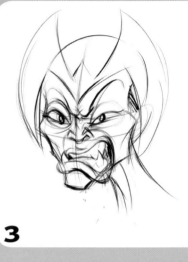

**3**

## 1 Draw the Basic Structure

For this demo our villainess will appear in a three-quarters view. Draw an oval shape for the cranium and add construction lines for the eyes, nose and mouth. The face should be somewhat squashed and not too narrow for this expression. Notice how the head juts out from the neck.

## 2 Block In the Features

Draw her lower lip pulled down in one corner for an extreme frown. Draw her mouth open with gritted teeth. Make her brow lowered and squinched together, and her nostrils flared.

## 3 Add Details

Refine the features and add details such as wrinkles. Be sure to indicate the cross-eyed stare. Darken the lines you intend to ink.

## 4 Clean Up

Keep the lines showing the contours of the helmet shiny. Use heavier lines for areas in shadow, such as inside the mouth and around the nose and chin.

## 5 I Don't Like Your Silly Face Mask

Sickly green is the color of a sick mind.

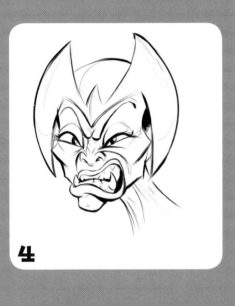

**4**

**5**

## Growling Variations

**Bronze**
Arrgh!........
Arrrrrrrggh!

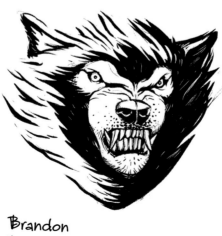

**Brandon**
Animals are really great at growling.

**Ben**
Caution: Do not steal food from squirrels!

# YELLING
Captain Thunder heads into the fray full throttle. He's holding nothing back, so we're going to show all his energy unleashed in his facial expression.

**1**

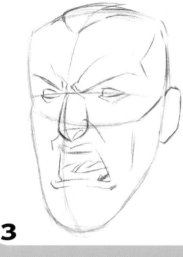
**2**

**3**

## 1 Draw the Basic Structure
Start with a head shape similar to the one on page 112, but elongate the jaw because he's going to be yelling.

## 2 Block In the Features
Draw the mouth wide open, with a frown and a sneer. Draw the half-moon for the bottom row of teeth. The eyebrows should be pulled down, with the Corrugator muscles running in full gear.

## 3 Add Hair and Refine the Features
Sketch in the hair. Add the furrows in the brow and other lines that indicate the effects of the expression.

## 4 Add Details
Indicate the highlights in the hair. Draw additional lines on the tip of the nose and the forehead to show how the rest of the face ripples as his muscles tense. Add details to the teeth.

## 5 Clean Up
Ink your drawing. Keep the hair glossy and darken the mouth. Add additional detail lines to show the stress and form of the face.

## 6 Hey There, Greenie!
Use the same cool and eerie color scheme for big Captain T. Add hard shadows to emphasize the direct light.

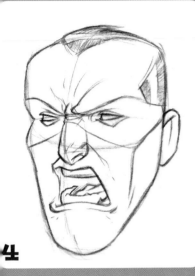

**4**

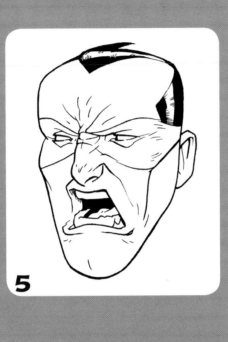

**5**

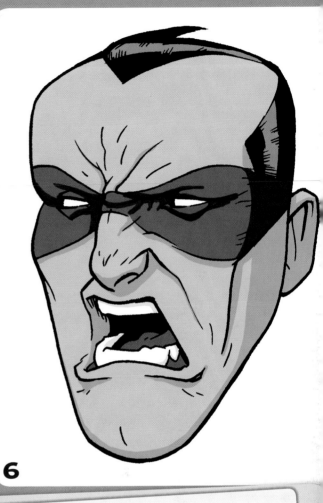

**6**

## Yelling Variations

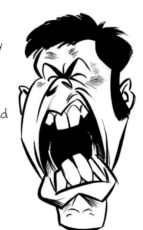

**Gibbs**
This is a pretty extreme and goofy yell, but it's also a yell of anguish and despair.

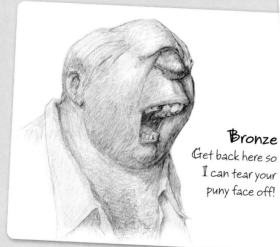

**Bronze**
Get back here so I can tear your puny face off!

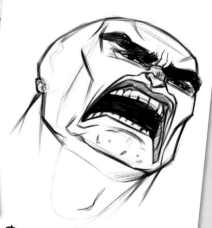

**Ben**
Hey! Try hitting it out to left field, sissy pants!

# ATTACKING

Infuriated, Serpentra attacks, lunging like a viscious serpent. How angry she must be to attack with such ferocity!

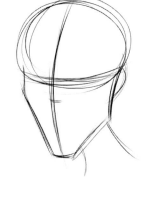

**1**

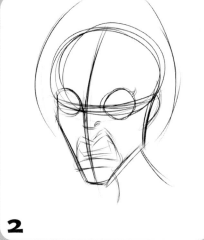

**2**

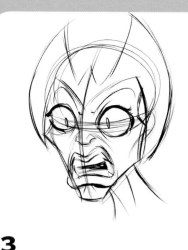

**3**

**1 Draw the Basic Structure**
Start with the same basic shapes and construction lines described on page 114, but this time elongate the face to accommodate her open mouth.

**2 Block In the Features**
Draw her lower lip pulled down in both corners for an extreme frown. Her mouth is opened extremely wide and her teeth are apart. Draw her brow lowered and squinched together and her nostrils flared.

**3 Refine the Features and Add Details**
Refine the features and add details such as wrinkles. Be sure to indicate the cross-eyed stare. Draw the irises vertical as if they too are strained and stretched. Darken the lines you intend to ink, especially around the eyes so they appear to pop out of her skull.

**4 Clean Up**
Keep the lines near the edge of the helmet so it appears shiny. Use heavier lines for areas in shadow, such as inside the mouth, around the nose and chin and around the eyes. Erase any pencil marks.

**5 Add Color**
Nyeeeeehhhh!!!!

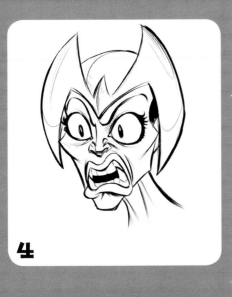

**4**

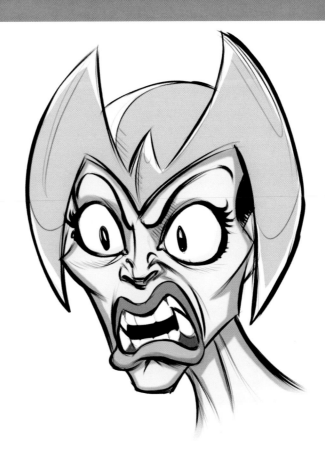

**5**

## Attacking Variations

### Bronze
This is the most terrifying killing machine in the galaxy: Kevin.

### Brandon
This is one of those expressions that needs body language to really sell it. This guy's expression could read a lot of different ways, depending on what his body is doing. In this case, imagine that he's running at you with big jagged zombie claws.

### Ben
Biting the curled-back tongue right before an attack is a trademark among the siblings in my family.

# SLUGGED IN THE GUT

Captain Thunder is smart, but he's lost some of his edge over the years. Between his blows, Serpentra sneaks a sucker-punch to the kidney.

In this demo, you'll draw the moment of Captain Thunder's most intense pain. This is the frame you must show to tell the story properly. In animation, it's called the "extreme."

**1**

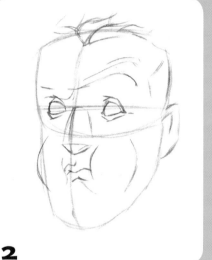

**2**

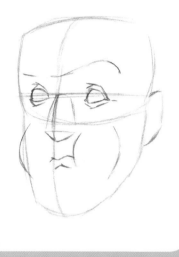

**3**

**1 Draw the Basic Structure**
Draw the head shape described on page 112: a typical superhero head shape with a big chin.

**2 Block In the Features**
Draw his cheeks puffing to show the air in his lungs being forcefully expelled. Draw his eyes wide open in shock, and his lips pursed together as he tries to hold it all in.

**3 Refine the Features**
Block in the hair, making it a little messy. Describe more of the form of the lips, cheeks and wrinkles on the forehead.

**4 Add Details**
Add the mask and solidify the most important shapes. Use a zigzag for the highlight of the hair to follow its messed-up pattern. Add sweat beads to show the slightest panic slipping into his psyche.

**5 Clean Up**
Ink your drawing. Make sure that any details you add follow the contours of the form.

**6 Ooohmpf!**
Add simple color to the design.

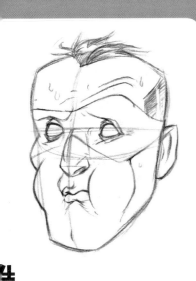

**4**

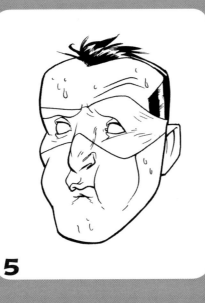

**5**

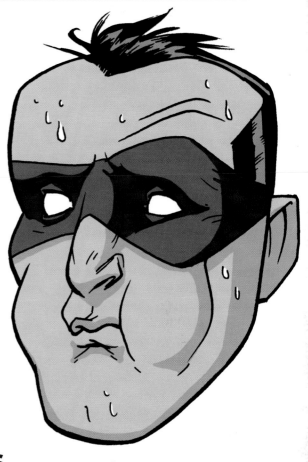

**6**

## Slugged in the Gut Variations

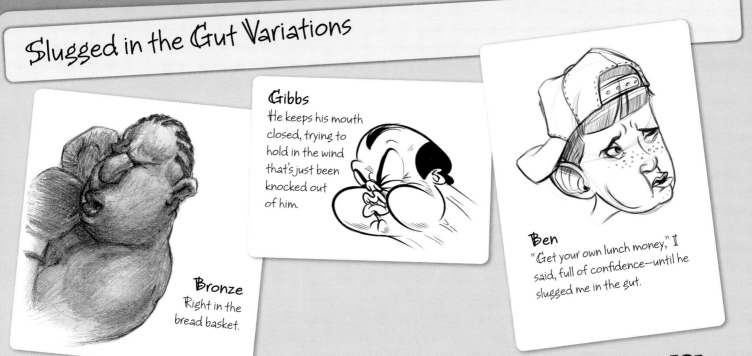

**Bronze**
Right in the
bread basket.

**Gibbs**
He keeps his mouth
closed, trying to
hold in the wind
that's just been
knocked out
of him.

**Ben**
"Get your own lunch money," I
said, full of confidence—until he
slugged me in the gut.

# ELECTROCUTED

When I approached this expression, I thought about the time that I was electrocuted. A friend of mine hooked a battery to the sink as a practical joke. I laugh about it now.

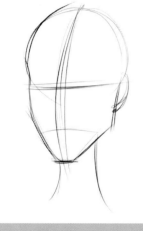

**1**

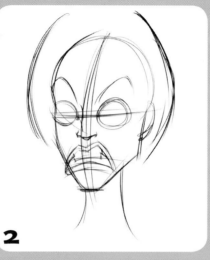

**2**

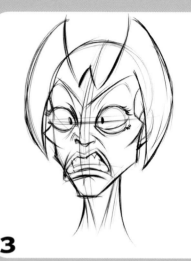

**3**

## 1 Draw the Basic Structure

Draw the structure for a three-quarters view as for the demo on page 118. Again the face will be elongated, but for a different reason: it will be absorbing the electric bolts that are sent upward through her body. Make her head sit straight up on her neck.

## 2 Block In the Features

Block in the main shapes. Draw her lower lip pulled down for an extreme frown. Her teeth should be clenched. Draw her eyebrows raised dramatically over her bulging eyes.

## 3 Refine the Features

Add pupils to her crossed eyes and wrinkles to show tension in her face and neck. Sketch the form of the helmet.

## 4 Add Details and Clean Up

Add electric current lines to the top of the helmet. Also, add burn marks to her face to give her a singed appearance. Ink your drawing, remembering to vary the thickness of the lines.

## 5 Zapped

I usually color my stuff using Adobe Photoshop. I use one layer for flat color, and then add a second layer for details like highlights and shadows.

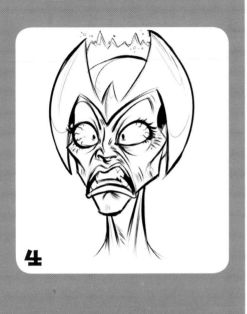

**4**

**5**

# Electrocuted Variations

**Bronze**
Electrocuted
to the max.

**Brandon**
I'm just copying
Gibbs here.

**Ben**
I don't know what to
think of this sketch.
Apparently, being
electrocuted is no
laughing matter.

# EXHAUSTED
Captain Thunder has given his all to bring down Serpentra, but it hasn't been enough. His strength is completely sapped and he's gasping for breath.

In this demo we're pushing Captain Thunder to the extreme again. His body is totally taxed, and his exhaustion shows in his eyes and in the way he breathes. Think of what must be racing through his mind: he knows he has nothing left to give and is scrambling to find some way to get out of this alive.

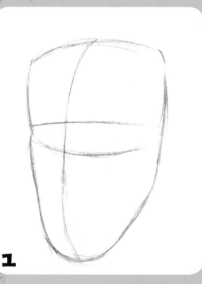
**1**

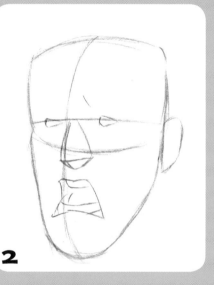
**2**

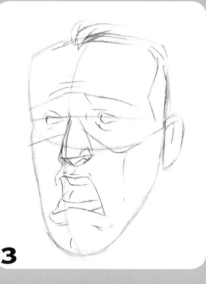
**3**

## 1 Draw the Basic Structure
Draw the head shape with an elongated jaw as you did for the demo on page 116. Captain Thunder is going to be gasping for air, so you'll need room for his open mouth.

## 2 Block In the Features
Draw the mouth shape similar to the yelling mouth on page 116, but notice that the lower lip is droopier. Make the eyes a bit more open, round and relaxed.

## 3 Refine the Features
Add lines around the eyes and under the eyelids to make them look heavy and puffy. Sketch the hair and the upward push of the eyebrow. Start to sketch in the mask.

## 4 Add Details
Indicate the highlight and shadow areas of the hair. Add details to the nose and mouth, and draw some beads of sweat.

## 5 Clean Up
Ink your drawing, remembering to vary the thickness of your lines.

## 6 She's (Huff) Too (Puff) Fast!
His face is making some more interesting shapes here. Use shading to describe its forms.

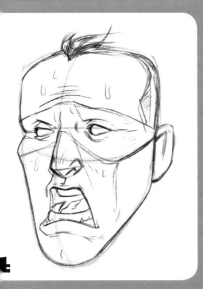

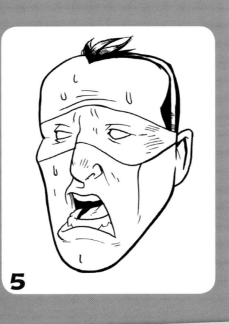

**5**

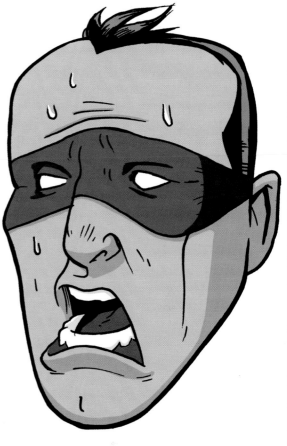

**6**

# Exhausted Variations

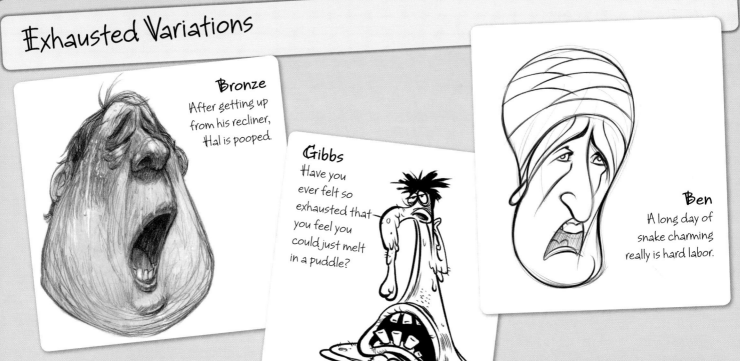

### Bronze
After getting up from his recliner, Hal is pooped.

### Gibbs
Have you ever felt so exhausted that you feel you could just melt in a puddle?

### Ben
A long day of snake charming really is hard labor.

# GLOATING

The villainess laughs, her ego boosted as she watches her worst foe crumple to the ground. To help me develop this expression, I thought of a time when I wasn't as good at this one video game as my friend. He would always rub defeat in my face.

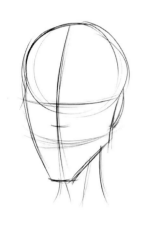

**1**

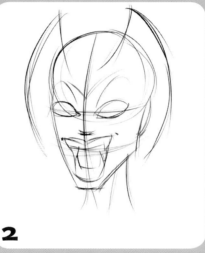

**2**

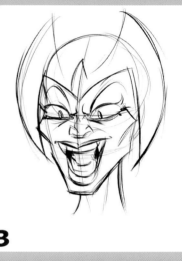

**3**

**1 Draw the Elongated Oval Shape**
Draw the basic head shape as you did for the previous demos, elongating the face to accommodate the open mouth. The neck will not be quite as stretched in this view.

**2 Block In the Features**
Draw her upper lip pulled upward in the corners for an extreme smile. Her mouth should be open very wide and her teeth should be apart. Make the eyes more relaxed and almond shaped.

**3 Add Details**
Add the rest of the features and the details. Draw the mouth more open and relaxed. Push the corners of her lips into a sinister smile. Relax her neck by playing down the wrinkles.

**4 Clean Up**
Keep the helmet shiny by leaving the bulk of it white with dark, contrasting edges. Darken the eyebrows and the areas in the mouth. Add detail to the mouth and eyes, but don't separate the teeth as much as before, she no longer needs to be viscious.

**5 I Won, I Won, I Won, I Won!**
Have fun picking your colors. Do something different and unique. Notice the colors in other art works, as well as seeking inspiration from nature and cartoon re-runs.

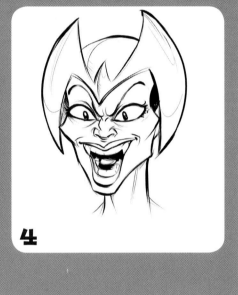

**4**

**5**

# Gloating Variations

**Brandon**
Okay, confession time. I originally intended this to be **seductive**, but it ended up looking much more like **gloating**. Sometimes, things just turn out that way.

**Bronze**
Da Boss just had someone whacked.

**Ben**
Look at that ant squirm. This glue works good!

# COWERING

He's defeated. Captain Thunder collapses into a pitifull shell of a man, pleading for his life.

   In this expression you're going to get very, very specific. Captain T's face shouldn't be symbolic of all cowardice, but specific to this place and moment. Imagine he's on his knees begging for his life; all thought of dignity has gone out the window. We want this vulnerabiltiy to contrast sharply with the masculinity and confidence that we've presented previously.

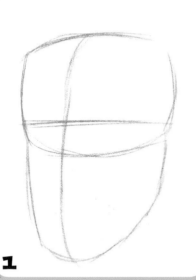
**1**

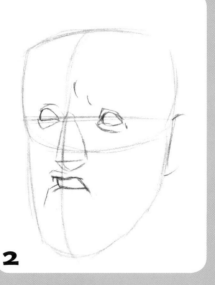
**2**

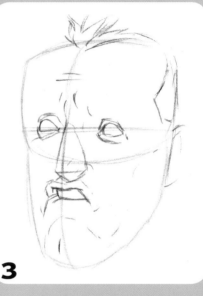
**3**

## 1 Draw the Basic Structure
Start with the same basic shape you used in the first demo with Captain Thunder: a blocky cranium with a prominent jaw.

## 2 Block In the Features
Draw the teeth biting his lower lip and his top lip jutting out, as if he were just beginning to cry. His eyes are open wide, focused on Serpentra, and his eyebrows are curled up.

## 3 Add Hair and Facial Details
Draw his hair, still messed up, but settled a bit. Add more stress lines around his eyes, and wrap lines around the form of the top lip to describe it well. Draw a crease in the bottom lip where his teeth are pushing down into the skin.

## 4 Refine the Form
Continue to use lines to describe and emphasize form. His nose, top lip and bottom lip should all look like solid, dimensional forms. Darken under the top lip and add detail to his hair and mask.

## 5 Clean Up
Add highlights to the hair as you've done previously, using a single highlight patch with small ink strokes cutting into it to soften the edges.

## 6 P-p-p-p-please, No More!
Add a little color, and you're done.

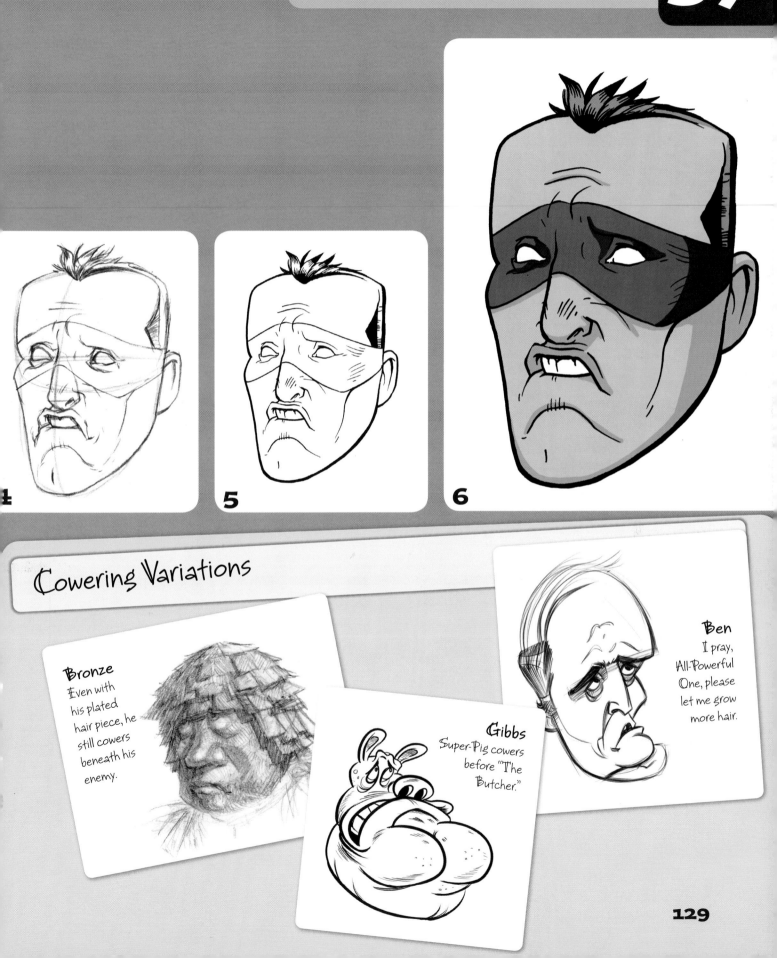

**4**

**5**

**6**

## Cowering Variations

**Bronze**
Even with his plated hair piece, he still cowers beneath his enemy.

**Gibbs**
Super-Pig cowers before "The Butcher."

**Ben**
I pray, All-Powerful One, please let me grow more hair.

**129**

# Love Is in the Air

Ahhh, love: the greatest of emotions—and ahhh, the facial expressions that come along with it. Love and attraction, the lure, the chase, the relationship—they are all so complicated.

The expression on one's face may be hidden or obvious. Bronze is going to draw the obvious (obviously!), and he'll show them on a little lady named Louise. She's come to the park and laid out a lovely spread for this summer day. But with whom can she share the experience? She nests strategically next to a strapping young man wearing a fine pair of sunbathing trunks. Now she must restrain herself so she doesn't come off as desperate.

## ARTIST'S NOTE

Of course they wanted **me**, almighty Bronze, to illustrate this love scenario because they thought, "Oh, surely a handsome man like that is very familiar with the eager looks of love from many fine ladies." It's true: I **am** familiar with those looks—but not from real life. I've just seen them in movies. (Sigh)

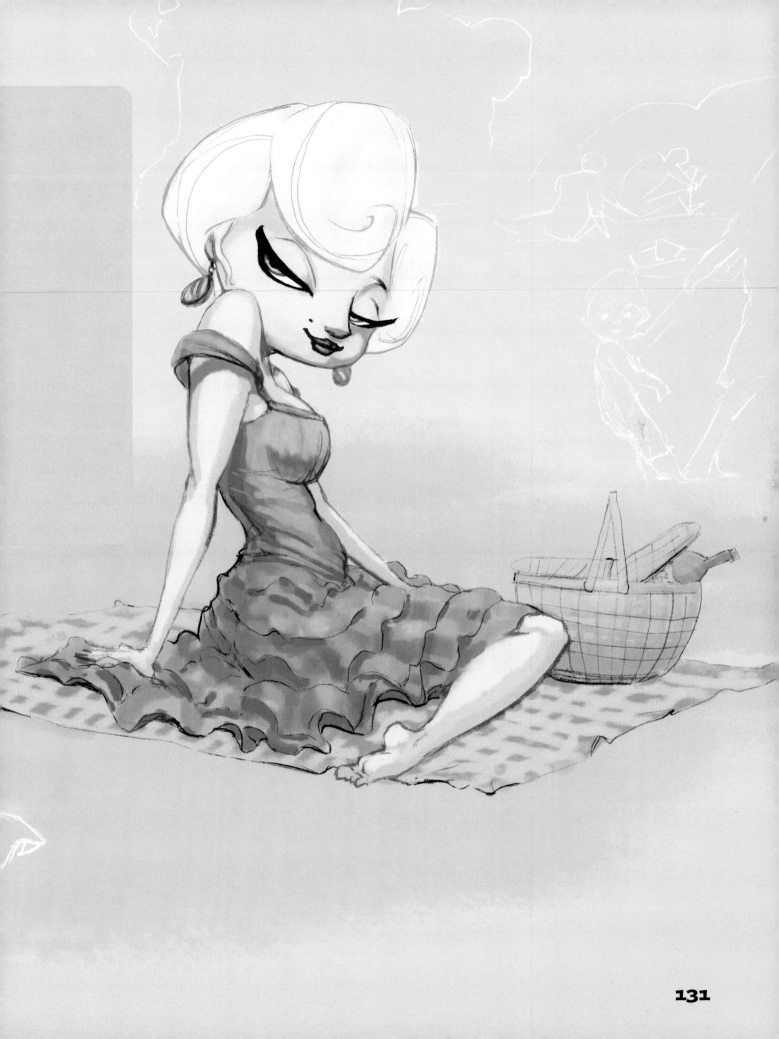

# SHY

Louise notices being noticed and is caught off guard by the glance from the hunky man. She's also caught off guard by his amazing buttocks.

For SHY, I'm going to show her looking down and avoiding eye contact, an action commonly associated with shyness. We'll also tuck her chin into her chest so she has to peer out through her eyelashes.

1

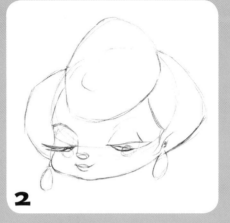

2

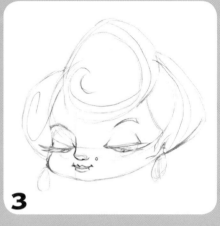

3

## 1 Draw the Basic Structure

Lay out the head shape. Remember that Louise has soft, childlike features such as a pronounced forehead and round cheeks.

## 2 Define the Features

Now lay in the eyelid line and have her eyes looking down and off to one side. Draw an ellipse for the lips and a slight smile. At this point, you can also draw the hairline and define the mass of the hair.

## 3 Add Details

Add the nostril contour of the nose and sharpen its perky look. Add a divot to the lips and define the eyelashes and eyebrows. Notice the small 45-degree lines at the ends of her smile. These make her smile look tighter. Add a beauty mole above her lip.

## 4 Clean Up

I had trouble finishing the eyes because her eyelashes cover so much of them, making it hard to tell where she's looking, but I settled for this and it seems to be enough information. For the cleanup on this demo I was concerned that I would lose the softness of her features by using ink, so I decided to finish with pencil instead.

## 6 Awww!

Of course, she's a blonde! Color your drawing with tones that suggest a bright, sunny day. Just add a simple shadow and mid-tone.

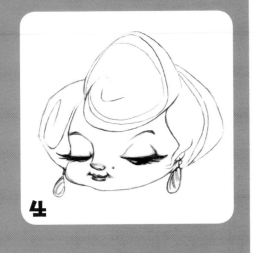

**4**

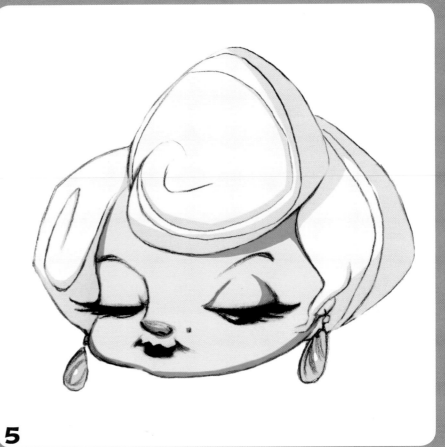

**5**

## Shy Variations

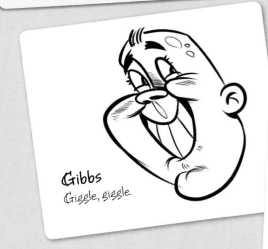

**Gibbs**
Giggle, giggle.

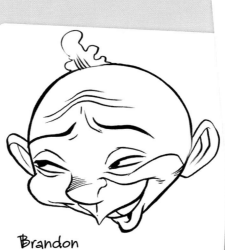

**Brandon**
This time shy is **shy**. I imagine this is a guy who is so shy, it's painful.

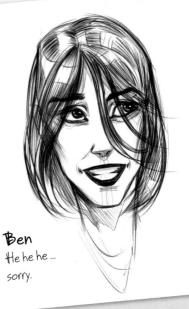

**Ben**
He he he ...
sorry.

**133**

# COY

COY is shy but inviting, with a guarded smile. Louise is playing coy, and the gentleman in the European swim trunks is taking the bait. Who wouldn't?

**1**

**2**

**3**

## 1 Draw the Basic Structure
Draw the basic shapes tilted. I threw in a shoulder to, well, show that she's looking over it.

## 2 Define the Features
Draw her upper eyelids low to give that alluring look. Draw her eyes looking over her shoulder and a more relaxed smile than the shy one. Add an ellipse for the lips. I drew her dress strap slipping below her shoulder to add a little more spice. Don't forget to add the mole above her lip.

## 3 Add Details
Pay close attention to where you place the eyelids and the eyelashes; this is the where the mystery and coyness will shine through. Draw extra lines through her hair to show direction and shape. Don't space them evenly through the hair, but vary the spacing and draw most of them closer to one side of the hair.

## 4 Clean Up
Darken the eyelashes and pupils. Shade the lips, leaving soft highlights to add dimension and make them look full. I'm leaving the rest pretty light because I want the focus to be on her eyes.

## 5 That "Come Hither" Look
I tried to use the most seductive red for the lips and blue for those smoky eyes. The light direction is from above, which is standárd. I'm still so impressed with my nose; have you ever seen its equal?!

**4**

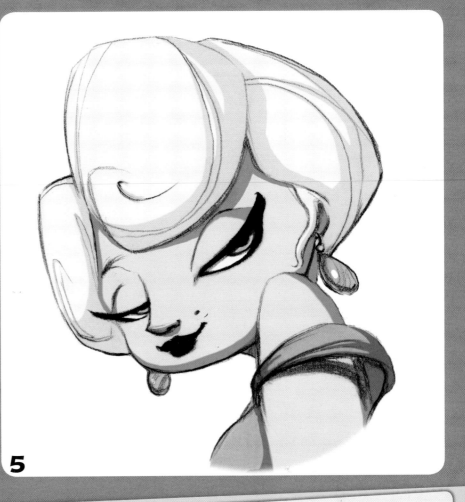

**5**

## Coy Variations

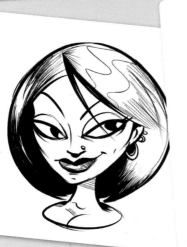

**Gibbs**
She likes you, and wants you to notice her.

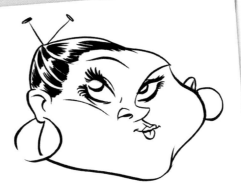

**Brandon**
Coy is usually a passive emotion, but I wanted to try showing a character using coyness to get what she wants. Here, acting coy is part of the game.

**Ben**
This subtle expression is much harder to pull off on a realistic character.

# SEDUCTIVE

Louise now feels that her subtle glances at the almost-naked man have been noticed, but with no clear advances from him apart from a smile, she must let him know that she is indeed interested. Not only interested, but very interested. She must let him know that he can do with her what he may.

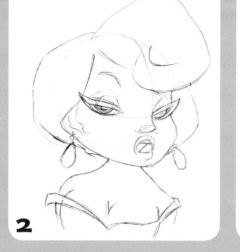

1

2

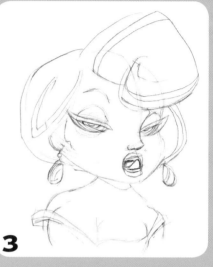

3

### 1 Draw the Basic Structure

Draw the basics for a three-quarters view. Her bangs are a bit more pronounced when we see them from more of a side view. I'm cheating by drawing her shoulder and bust, which, of course, add to the mood we are trying to create.

### 2 Add the Features

Draw her upper eyelids low again. We want those alluring "bedroom eyes," but there is nothing shy about her eyes now that they are fixated on her prize. Draw her mouth open but her lips relaxed. Because her mouth is open, her lips will appear more like soft tube shapes, and we'll see her teeth a bit. Draw her tongue touching her top teeth. Her eyebrows should be slightly raised, and one could be cocked a bit to create a questioning look that asks, "Do you want me?"

### 3 Add Details

Further define the curve and shape of her tongue and nose, and add hair details. I'm adding curved lines in her earrings to suggest that they might be made of polished stone or wood. I modified her eyebrow slightly to make the peak of the arch more toward the inner side. This sells that inviting look.

### 4 Clean Up

Darken the eyelashes and pupils. Shade her lips with a long, narrower highlight to give them a soft, tubular look. Define her teeth and shade her tongue so that it's darker on the bottom but catches more light on the top as it comes up and back to touch the teeth. I added subtle cast shadows under her bangs and chin to give her a little dimension.

### 5 Interested?

Some of the form should have already been described in the initial sketch. Follow the shadows and form you've already created to determine where to put the color.

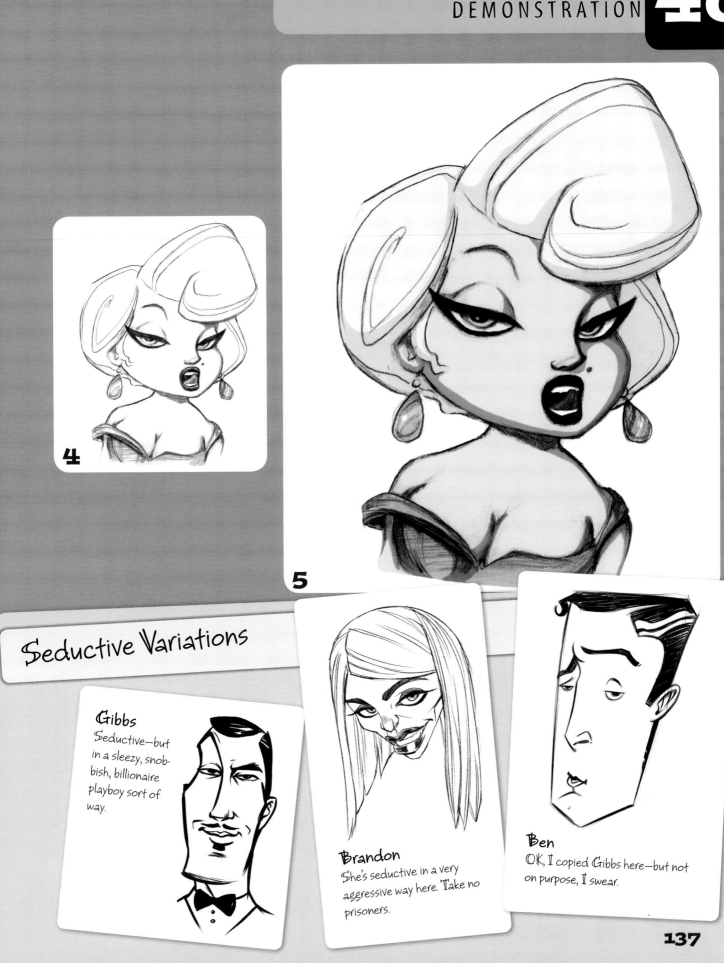

4

5

## Seductive Variations

**Gibbs**
Seductive—but in a sleezy, snobbish, billionaire playboy sort of way.

**Brandon**
She's seductive in a very aggressive way here. Take no prisoners.

**Ben**
OK, I copied Gibbs here—but not on purpose, I swear.

# INFATUATED

Now her desire for the gentleman's attention has dissolved all the self-restraint Louise once had. "I must have him and now!" she shouts in her mind. Unleashed, she advances with a crazed look in her eye that would frighten any man.

What sets this expression apart from CRAZY is the smile accompanied by the prominent tongue. She looks as though she's about to devour something.

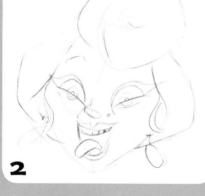

**1**

**2**

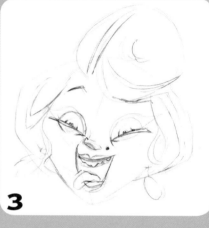

**3**

### 1 Draw the Basic Structure
Because her mouth is wide open, her cheeks are drawn downward and are not as full. Infatuation has sent Louise's hair a bit upward.

### 2 Add the Features
Draw her lower eyelids arched up to show that she's smiling. By keeping her upper lids all the way open, we create that crazed look. Draw a line across her mouth for teeth, and an off-kilter ellipse for her nose. You can draw the tongue doing almost anything, but I liked it arching out to the side. Her upper lip is curled up a bit, so let's exaggerate the points of her lips.

### 3 Add Details
I'm not sure why people snarl their noses when they lust after something, but they do. I raised one nostril, but you can raise both if you like. I took a couple of teeth out, because it seemed to add to her character.

### 4 Clean Up
I accentuated the line from her mouth to her nose a bit to show that snarl. Draw a little highlight on each pupil for her crazed eyes. That highlight seems to go along with the phrase: "You've got that crazy gleam in your eye."

### 5 Whoa!
Run for your life!

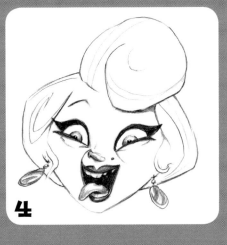

**4**

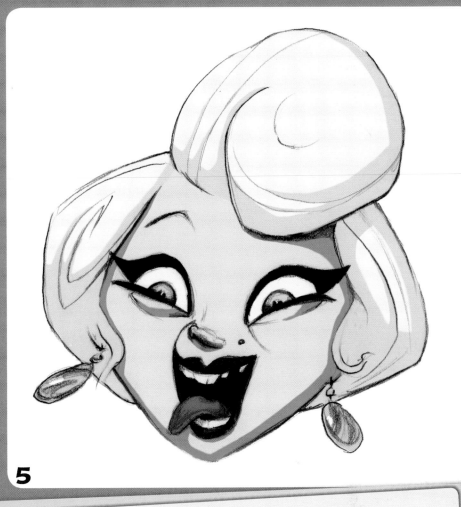

**5**

## Infatuated Variations

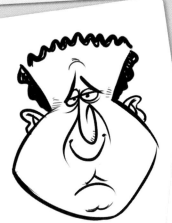

**Gibbs**
This guy is really in love, even though the girl has no idea he exists.

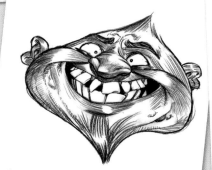

**Brandon**
This one crosses the line from infatuated to kind of pervy. (It's a thin line.)

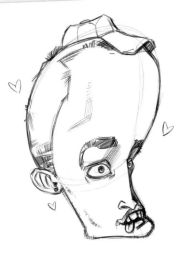

**Ben**
Check out them new set of snow tires! I's infatuminated.

# 3 Storytelling

Now that we've explored expressions pretty thoroughly, we're going to look at how to use them in actual storytelling situations. As we've discussed before, expressions are always reactions to something. In this section, the demos are all about characters reacting to other characters. This means that we'll be crawling inside the head of each of our characters and feeling what they are feeling, even if only for a moment. To do this we need to understand points of view. Specifically, we must understand how characters see each other, and how the point of view affects their reactions and expressions.

While color does play a big part in telling the story, we really want to focus on the importance of storytelling, point of view, body language and composition. When you compose a frame, imagine that you are seeing that shot through the eyes of one of your characters. How does that character feel about what he or she is looking at? The answer should help you decide how to frame your shot. So, are you ready to get serious?

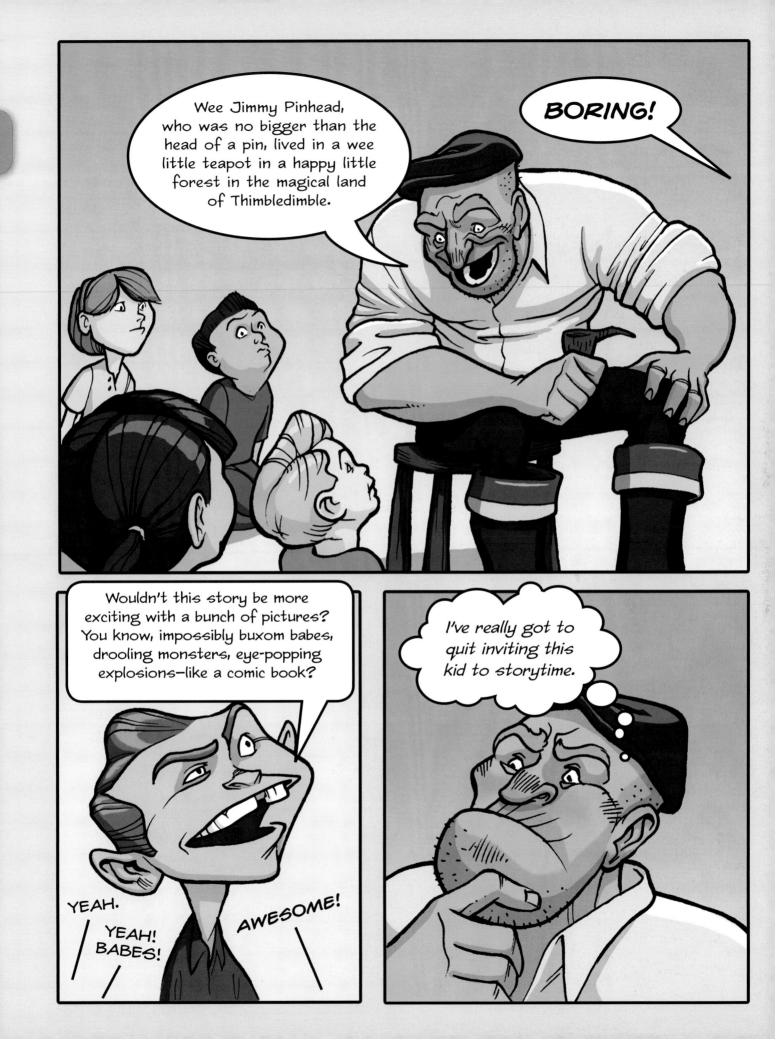

# Framing

The type of information you want to convey to your audience will determine how you should frame each part of your story. Framing options include closeups, medium shots and long shots, but those general categories encompass an infinite range of possible views.

**Medium Shot**
A straight forward view of a clown crying.

**Closeup**
This view of the clown's eyes allow us to focus on his tear.

## CLOSEUPS

Closeups are about focusing on details. A closeup says, "This thing we're looking at right now is important—more important than all the other stuff around it."

Closeups put your audience in physical proximity to your subject. This can be a way of communicating intimacy and warmth, as when we cut tightly into lovers' faces, or a way of communicating awkwardness or revulsion, as when we focus on all the warts, zits and rotten teeth of a thug.

Closeups always require more detail, but it's up to you to decide which details are most important. If you want to focus on the reaction of a specific part of the face, then draw an extreme closeup of that feature.

**Extreme Closeup of an Eye**
This view is intimate and revealing.

**Extreme Closeup of a Mouth**
This view shows someone who is happy and healthy.

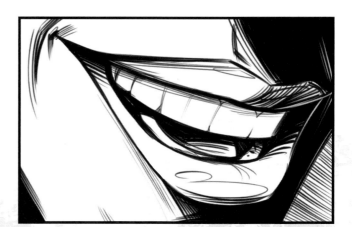

## CLOSEUPS PROVOKE RESPONSES

Showing intimate details—especially of a character's face—can provoke strong emotional responses from your audience. Use closeups to focus those reactions and create the right feeling for your story.

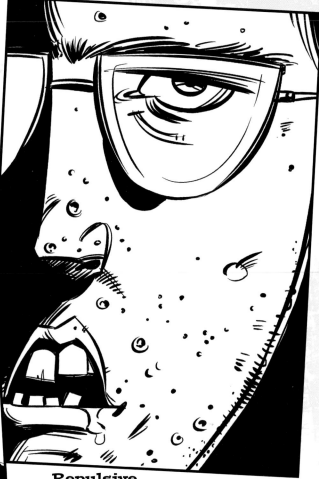

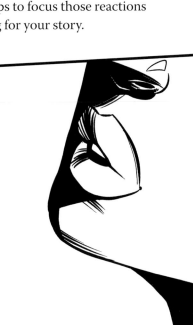

### Enticing

This alluring mouth brings your audience close enough to almost feel the kiss.

### Repulsive

The details of this ugly face are sure to repel your audience.

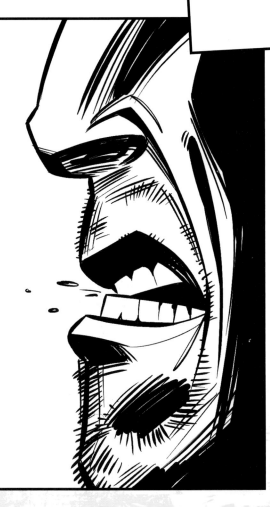

### Closeup of a Nose and Jaw

This view of a grizzled face emphasizes the character's nastiness.

## LONG SHOTS

On the other end of the spectrum is the long shot. Long shots are used to emphasize and describe environment. Typically, the first panel in a comic book will be a long shot (called an *establishing shot*) that tells us where the action is taking place. Long shots can also be used to show distance between two characters, and describe how that distance causes them to react to one another.

### Describing the Environment

Long panel with a single small figure in the middle. We thought a knife-throwing act was the best and most common way to show long shots in action.

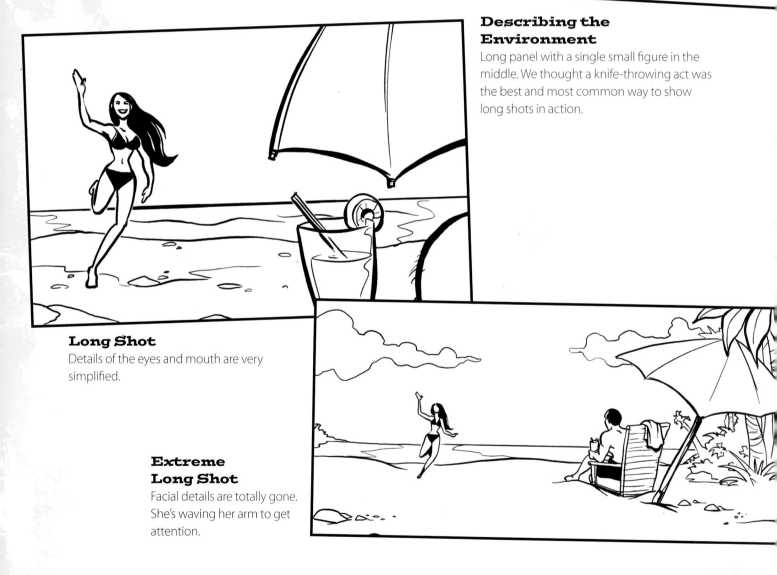

### Long Shot

Details of the eyes and mouth are very simplified.

### Extreme Long Shot

Facial details are totally gone. She's waving her arm to get attention.

## MEDIUM SHOTS

Medium shots are best for important facial expressions because they allow you to show a full face with a lot of details. As you pull back from the head to include more of the body, you will lose much of the detail, so you must decide how much detail you need to convey the necesssary information.

**Medium Shot**
Dull expression, dull mind.

**Long Shot**
Not very active in body, either.

## MAINTAINING EXPRESSION

The most critical details of any expression are the eyes and the mouth. As you pull away from the figure, the nose is often the first detail to go. As you can see from the examples at right, even with the nose gone, expression still reads loud and clear.

The farther away you go, the harder it is to read the expression clearly. You start to lose the pupils and the eyebrows, and can do less and less with the eyes and mouth. As your distance from the figure grows, it becomes increasingly important to use body language.

**Medium Shot**
You can see pretty much every feature of this woman's face.

**Long Shot**
Enough of the eyes and mouth remain to maintain the expression. Adding the stance of the body contributes another dimension to the attitude.

**145**

# Body Language

Think of the body as an extension of the face. If the face is compressed with anger, have the body do the same. If the face is bursting with energy, the body should explode as well.

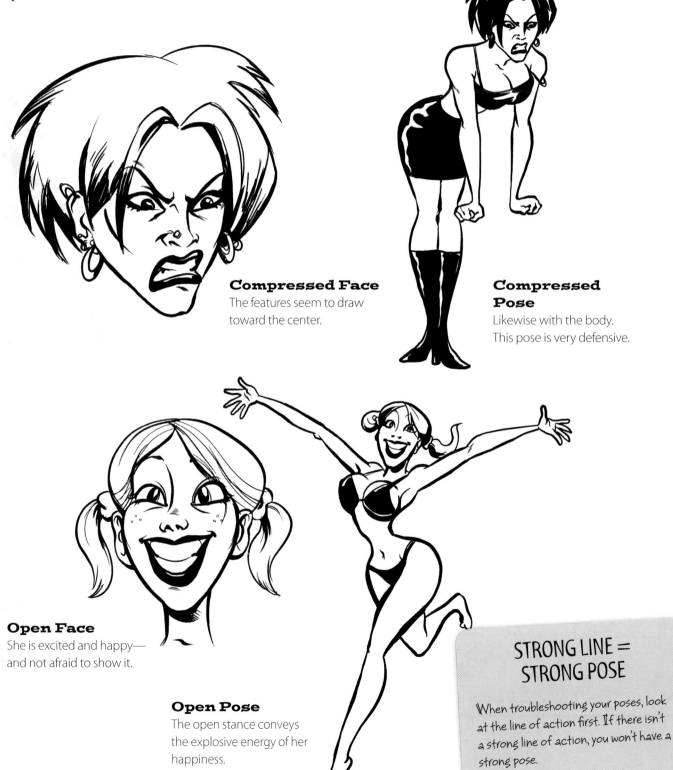

**Compressed Face**
The features seem to draw toward the center.

**Compressed Pose**
Likewise with the body. This pose is very defensive.

**Open Face**
She is excited and happy—and not afraid to show it.

**Open Pose**
The open stance conveys the explosive energy of her happiness.

### STRONG LINE = STRONG POSE

When troubleshooting your poses, look at the line of action first. If there isn't a strong line of action, you won't have a strong pose.

## LINE OF ACTION

The energy of a body can be most simply expressed through a line of action. A good line of action shows a specific, direct motion through the entire body, with all of the details reinforcing that line. A bad line of action moves all over the place, with a lot of little energetic details fighting against each other.

### Balanced Pose

This babe stands firmly on solid ground. The realistic pose displays a strong, balanced line of action. Her straightforward expression complements the pose.

### Unbalanced Pose

This girl may be hot-to-trot, but she seems to be floating in the middle of nowhere. Her pose has no clear line of action, and her expression doesn't relate to anything, either.

### Strong Line of Action

This compressed pose demonstrates a strong, dynamic line of action. Her expression is similarly compressed.

### Explosive Action, Explosive Line

The line of this energetic pose leads the viewer's eye to the knocked-unconcious face.

# ZOMBIE & CAVE GIRL

**SINGLE PANEL** When you are working with a classic genre such as "Cave Girl–Zombie" comics, make sure you know your sources. For this demo, Gibbs researched actual encounters between cave women and zombies. Just a little research can go a long way. Make the action pop by creating lines that are as dynamic as possible.

 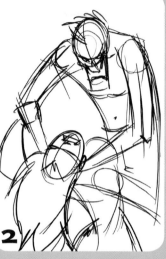 

**1 Create a Thumbnail**
These crude drawings are called *thumbnails*. They are usually very small, somewhere around 2" × 2" (5cm × 5cm). Thumbnails offer a very quick way to get my ideas down on paper, and the size prevents me from getting bogged down with details. I draw a thumbnail in less than a minute just to get an idea of how I want to compose the scene. This composition really makes the cavewoman the aggressor.

**2 Try a Different View**
I created another thumbnail with roles reversed and the zombie on top. It turned out OK, but if I redid it I would probably make the angle more extreme. I don't think I will go with this one.

**3 Explore Your Options**
Try another for exploration's sake. You might find something you like but didn't visualize until you pushed yourself to think differently. I like the equal struggle between the two characters a little better. Perhaps I would rotate the point of view a little to the right. The energy is in here somewhere, but I think I will go with the first view.

**4 Choose a View and Create a Rough Sketch**
Now that you have chosen your favorite thumbnail, create a rough sketch from it, using another sheet of paper. Block in more of the actual shapes and anatomy. I added lines to show how the bodies will be positioned, and a hint of the final expressions.

**5 Add Details**
Now lay a new sheet of paper over the top of your rough drawing. Can you see through it? Kind of? If you can, use this as your guide to creating the final, tight version. If you can't, try a light table. At this point, you can add all the details, figuring out how such things as those fingers should look.

**6 Dead Guy, Meet Cave Girl**
Finally, ink and color your beautiful drawing. Remember to vary the width of your strokes to accent your curves and lines.

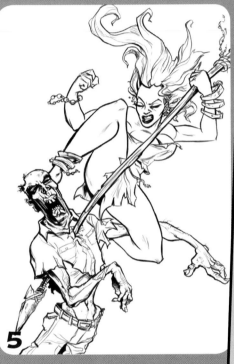

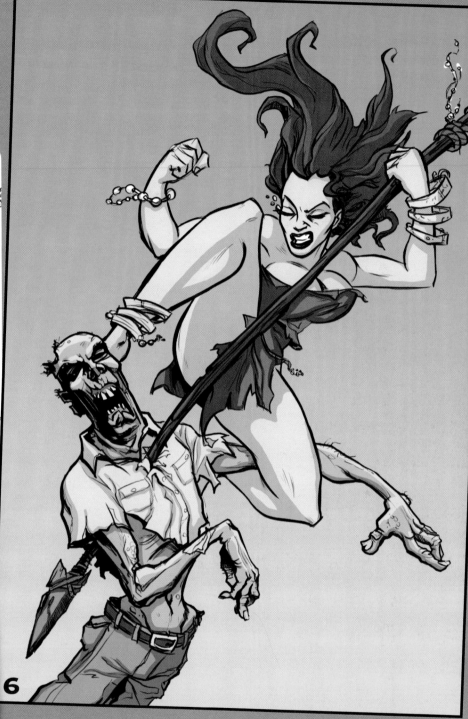

## KEEP A SKETCHBOOK

Keep a sketchbook and fill it with thumb-nails of all those crazy ideas in your head. This will be a valuable resource later on when you're trying to think of something cool to draw. It won't take a whole lot of time, either.

# SPACE MAN VS. ALIEN MONSTER

**SINGLE PANEL** Space, the final horizon ... no, wait, I mean the other thing! Something about space and the unknown has fascinated artists for a long time. For Ben, this subject still packs a lot of excitement. In this single-panel demo, Ben will show how he composes a scene for maximum impact, while allowing body language and facial expressions to take center stage.

### 1 Create Some Thumbnails
I use thumbnails as visual thoughts to explore composition ideas. To some they may just look like scribbles, but to me they make perfect sense. Don't worry about anatomy; establish a design that will tell the story. Create several thumbnails, even if you feel like you already got it down with your first one. This exercise will help you to stretch your thinking and may lead to ideas that you've never thought about before.

### 2 Refine the Drawing
Choose your favorite thumbnail and use it as a guide for your drawing. You can do this by just drawing a larger version on a new piece of paper, or you can enlarge it on a photocopy machine, then trace over that onto a new sheet. Rough in the figures, correcting anatomy and fixing those compositional details that didn't make it into the thumbnail.

### 3 Add Details, Tighten and Ink
If your rough sketch is tight enough and you feel you have all of the necessary details, you can begin inking it using your favorite tools. I took my sketch into the computer and inked it there, but the same effect can easily be achieved with pen and ink.

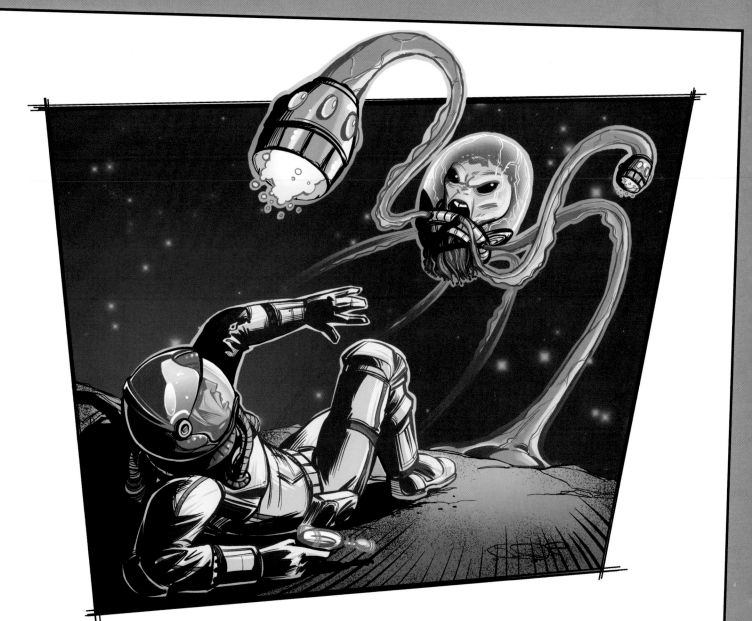

4

## Add Color
Ah, the final piece, beautifully colored. It's great to see the payoff after all of those steps. At this point it's a little late to evaluate the image, but I think this successfully shows the fear of being overcome by an angry alien creature.

## INKING INSPIRATION
There aren't really any rules for inking. It's all a matter of personal style. When you're learning the craft, open up a copy of your favorite comic book and see if you can reproduce the look and feel of the work. After much practice, your own style will eventually emerge.

# NOIR INTERROGATION

**TWO-PANEL:**
**Shot/Reverse Shot**
The NOIR style was developed by film directors of the mid-twentieth century and has become popular with comic artists as well. This genre is characterized by low-key lighting and dramatic camera angles. This piece will be set in the 1940s, so the clothing and hair should fit the time period. Blake is going to show us how to tell a story using the shot/reverse shot.

1

2

3

### 1 Create Some Thumbnails
Start creating thumbnails. With this one I was exploring the concept of shot/reverse shot. We have one view from behind the interrogator and one from behind the guy under investigation. I decided this doesn't work well because there isn't an establishing shot to show the setting and convey the relationship of the figures to one another.

### 2 Keep 'Em Coming
In this sketch I was playing with the body language of the interrogator. This is slightly better than the first thumbnail because we get more of a sense of where the characters are in relation to one another. I won't go with this one, however, because the two panels are too similar and don't heighten the drama.

## 180-DEGREE RULE

Put simply, this rule involves an imaginary line that runs between two points in a scene. In a scene with two characters, those characters are the points. Once you establish this line, you should compose all of your shots from the same side.

Shots from different sides of the 180-degree line are confusing. Here, the most effective designs show the characters from the same side of the line. As you compose your own sequences, experiment with jumping across the line to get a good idea of how this rule works.

### 3 Make Your Choice
At this point, you must decide whether to use the best aspects of your previous thumbnails or come up with something completely different. I chose to take what I learned from the first two drawings and tighten the idea. The body language makes the first panel more dramatic. I also like the angle of the table. The light between the figures heightens the drama. The first panel will show the expression of the man being interrogated; the second panel will be a reverse shot of the investigator's face.

### Refine and Add Detail

**4** I took the composition of the third thumbnail and expanded upon it. Here we can see the man cowering because he is being overwhelmed by the light and the interrogator's accusing finger. The reverse shot allows us to add more detail to the interrogator's face. The expressions should work together to tell the story.

### Tighten, Ink and Color

**5** Tighten your rough sketch, ink in your lines and finish it off with a bit of color. It sounds like a lot for one step and in a way it is; but when you take time to figure out the composition in the thumbnail and the expressions in the rough stage, the rest is just icing on the cake. Here is where I really added the noir-style elements. By coloring it in dark, muted tones, I conveyed the idea that this was the 1940s film noir era. The hat and slicked hair of the man under interrogation reinforce the time period. Gradations of tone behind the characters not only help to set the mood but also work as a compositional device to lead your eye.

# THE REMATCH

**TWO-PANEL:**
**Extreme-Angle Shot/**
**Reverse Shot**

Captain Thunder and Serpentra have unfinished business. Captain T doesn't take defeat well, and Brandon is ready to help him settle the score.

Conceptually, this two-panel is similar to the noir-style Interrogation (page 152): another shot/reverse shot. Here, each panel represents the point of view of one of the characters. Even though it may not be a literal point-of-view shot, each portrays the action as one character would perceive it.

In this demo, the angles are more extreme. The first panel takes a worm's-eye view; the reverse shot employs a bird's-eye view.

## 1 Create Thumbnails for Each Frame

Develop composition ideas for both frames. If your thumbnail is on the money, you can continue to tighten it up for the rough sketch (as I've done with the first panel here).

## 2 Tighten Your Drawing

Create a tight version of the thumbnail. Adjust the composition until you're satisfied with the feeling it conveys. Add details to emphasize the grotesqueness of Serpentra's hands and the determination in Captain Thunder's grimace.

## 3 Clean Up and Lay Out the Page

Clean up your drawing and lay out your panels on the page. In this case, I used a felt-tip pen for cleanup and I laid everything out in Photoshop.

## 4 Not This Time, Serpentra!

Now, slap some color in there for good measure. Notice how the white light coming from Serpentra's hands in the second panel heightens the drama!

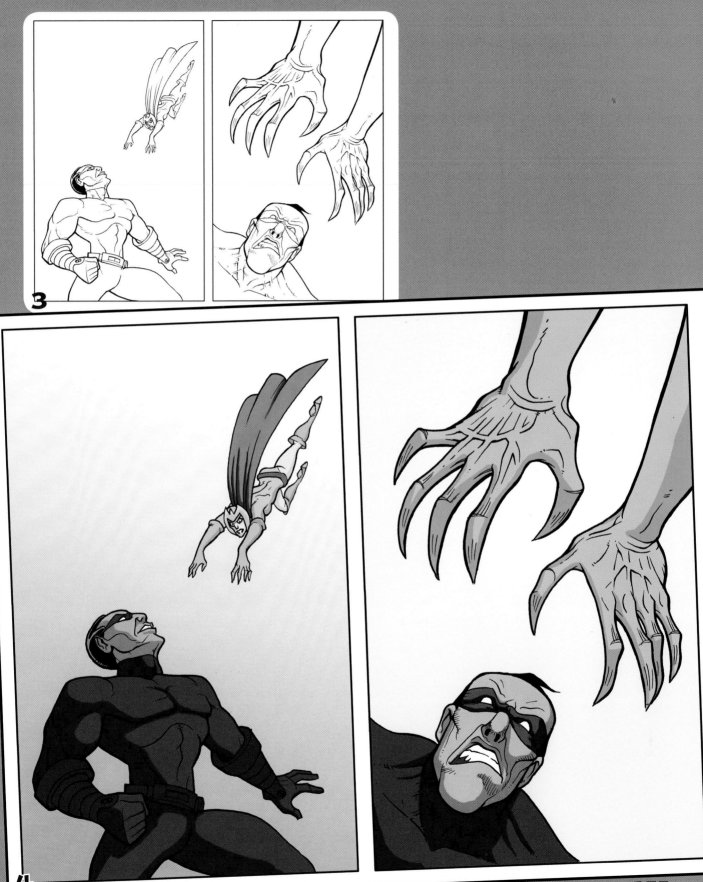

# WESTERN STANDOFF

**THREE-PANEL:
Establishing Shot
and Closeups**

Ah, the Western standoff. Is there any scene more iconic? More than likely if you are drawing a scene from such an old, common genre, you're going to be drawing scenes that people have already seen. This isn't necessarily a bad thing; it allows you to tell the story more easily because the images are so familiar. Listen to Blake, he knows what he's doing ... sort of.

1

2

3

## 1 Create Some Thumbnails

In this first thumbnail, I was playing around with how to set up the establishing shot and the other panels. This establishing shot seems too boring. I like the arrangement of the three panels, so I will explore that further.

## 2 Experiment With Angles

Experiment with different "camera" angles. The first panel here is a classic for the genre, but since we don't yet have a sense of who is who, it won't work. We need a better establishing shot.

## 3 Try Again

Time to push yourself. In this sketch, I tried the full-body establishing shot again, but with a more dramatic point of view. By placing a closeup of each guy on the same side where he appears in the establishing shot, we let the viewer know who's who.

## 4 Add Details

Now that you have an arrangement you like, tighten it up by adding details. This is where I really focused on the characters' expressions. In the establishing shot, the one in the distance has a tense, scared posture. The guy closer to us has a more confident, statuesque pose. I have arranged the bottom two panels to portray the two men staring into each other's eyes. Even though the arrangement has condensed the space between them, we know they are far apart because of the establishing shot.

## 5 Clean Up and Color

Clean up the drawing and add color to establish the lighting and mood. Standoffs always seem to be more interesting when set at midday. To indicate this, I painted the shadows directly underneath the figures. The form shadows also reinforce the idea that the the sun is directly overhead. The faces are in shadow because of their hats, but notice that because the sunlight is so strong, there is an intense reflected light from the desert ground below.

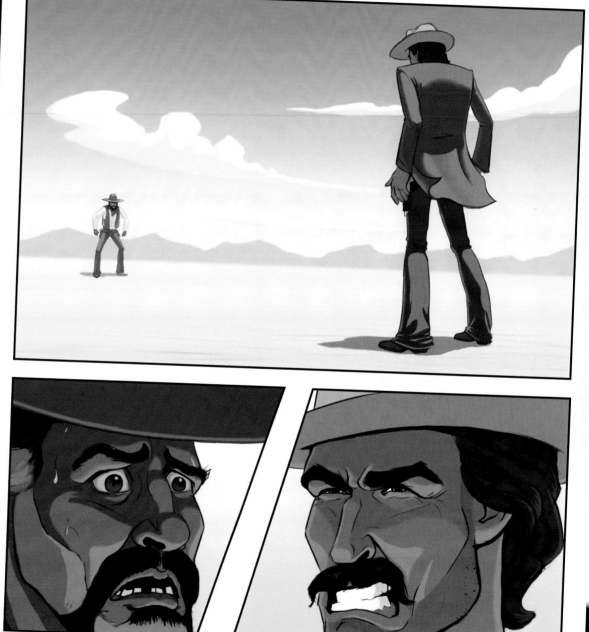

5

# MEXICAN STANDOFF

**SINGLE PANEL:**
**Sectioned With**
**Three Characters**

Now that we've looked at some ways to show two characters interacting in a scene, we'll throw in a third character to make things more complicated. What better scenario for three characters than a "Mexican standoff," which is basically the same thing as a classic Western standoff, but with three or more antagonists instead of just two.

In this demo, Brandon will compose three panels, each representing the point of view of one of the parties involved in the standoff.

1

2

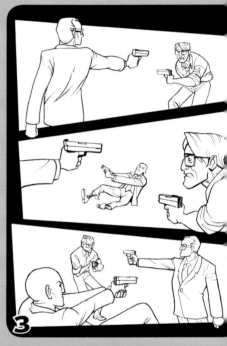

3

## 1 Create Some Thumbnails
Plan your rough layout. This is going to take the most thought and effort. Be prepared to redraw your composition until you get it right. If you're using pencil, use one that's easy to erase so you can make changes easily.

## 2 Tighten and Add Details
Tighten up your rough layout. Fix any anatomical and proportional errors and add dramatic details.

## 3 Clean Up and Ink
Clean up and ink your drawing. Use bolder strokes for figures that are closer to you, and lighter strokes for objects that are farther away.

## 4 A Bad Situation
Use colors to help distinguish the three figures from one another.

### 180-DEGREE RULE WITH THREE CHARACTERS

You can still use the 180-degree rule for scenes with three characters. Pick two figures to draw your 180-degree boundary through. The third character can be on either side of the line.

In this case, I drew my line through the guy holding his gut and the guy on the ground.

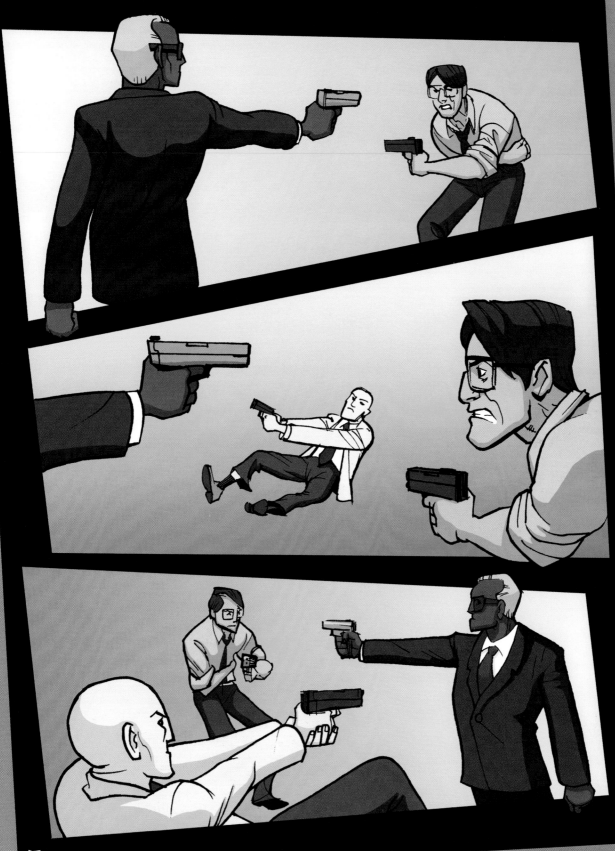

# DAMSEL IN DISTRESS

**SINGLE PANEL:
Three Characters
With Inset**

Insets provide a great way to tell the story from two different points of view. The inset allows you to zoom in to a specific area or pull back for a wide establishing shot. It's kind of like having a second camera. Ernie explains ...

### 1 Create Some Thumbnails

Begin sketching thumbnails and remember to keep them small. I started working fairly loosely, just scribbling in the bulk of the characters and their positions. I wanted to see the face of the damsel in distress and wanted to use the bad guy to frame the rescuer. The only thing I wasn't quite sure of at this point was what kind of head my villain had.

Using tracing paper, I explored another version of the villain's head. I liked how the big, bulky shoulder and arms in the suit contrasted with the skinny turtle neck.

### 2 Refine Your Rough

Because I have done a lot of drawing over these many, many years, I can go straight from rough to final line work. I know it's crazy. After drawing the three figures, I thought it would be really cool to get a look at the villain's eyes, so I drew them in an inset at the bottom. I'm not the kind of artist that uses a lot of black ink for the shadows. I try to describe the texture and use colors to add the shadows. I loosely ink in the outline of the character, then start adding the details. I accidentally crossed the wrinkles, but decided to keep them that way because they looked like elephant skin. Don't be afraid to explore different ways of doing things.

### 3 How Did You Guys Meet, Anyway?

Now, color it! I usually paint from background to foreground. Starting with a large background shape, I throw in a gradated color. Using a separate layer in Photoshop, I block in flat areas of color for the characters and props such as the gun. Then I add detail to the flat areas of color. If the background color isn't working, I can change it without affecting the character color layer.

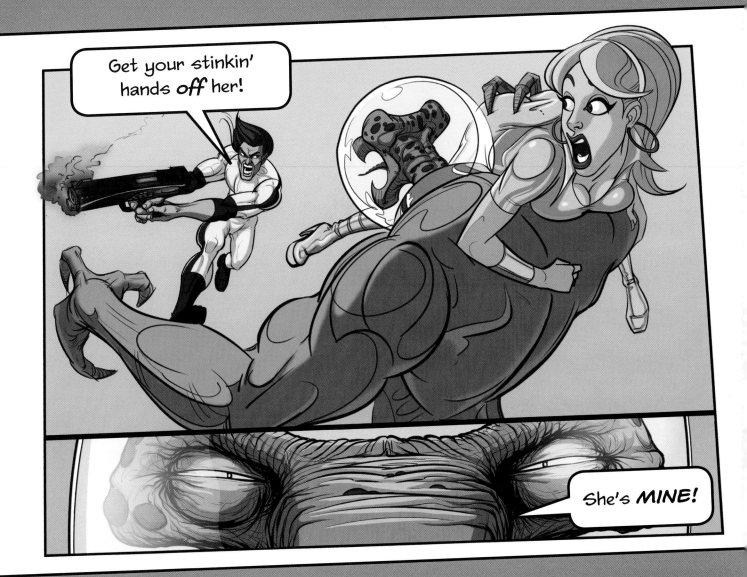

# SUPERHERO TEAM

**COVER:**
**Splash Page**

You know you've made it big when you get the opportunity to do a cover. And in case you forgot in all of the excitement, they are actually going to pay you for doing it! As cool as that may be, covers are tricky business. They can make or break the sale for someone who is browsing the shelves looking for something cool, so pay attention as Ben takes you step-by-step through the process of creating our Superhero Team cover.

## 1 Create Some Thumbnails
Think about the individuals on your team. How do they interact with one another? If each of them has different personality traits, how can you show that in the body language? Remember to keep your drawings small and don't worry about the details or correct anatomy.

## 2 Refine the Drawing
Choose your favorite thumbnail and use it as a guide to create a rough sketch. Establish each figure's proportions. Decide where and what you want to overlap. Rough in the particulars, correcting anatomy and fixing details that didn't make it into the thumbnail.

## 3 Ink
When inking, think about how lighting can influence the story. For example, side lighting with strong contrast can add interest, or backlighting that superhero with a ray of sunshine can make him stand out. You need to ink more black areas rather than just lines in this step.

## 4 The Good Guys
Now add color to your image. This can be done in any manner of ways including markers, watercolor, colored pencils, etc. But, if you want a professional look, it's best to take it to the computer and use a program like Adobe Photoshop or Corel Painter.

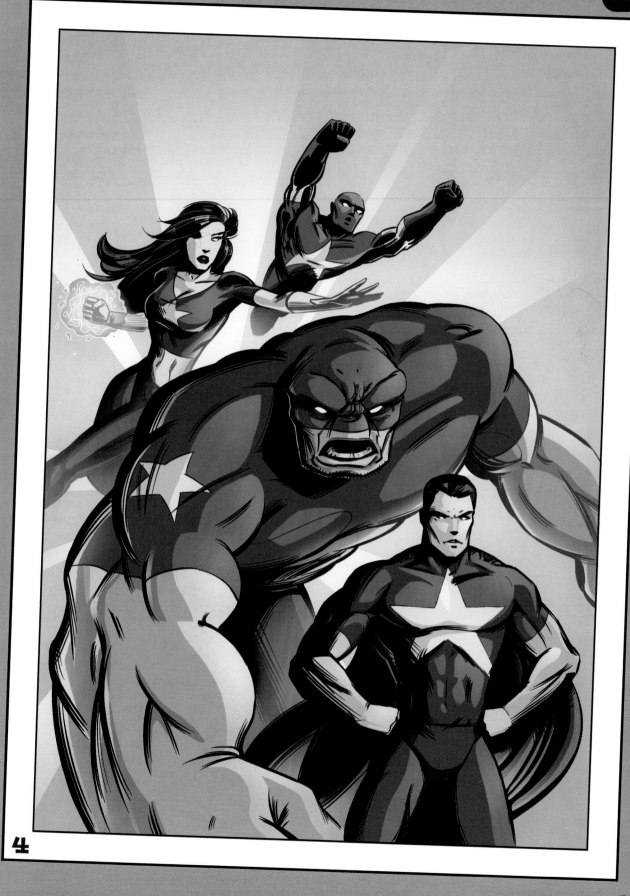

4

# SUPERVILLAINS

**COVER:
Splash Page**
Here's an odd collection of supervillainy: the brute, the fatty, the lackey and the genius, with the female as the leader. This demo will explore Gibbs's take on the team cover with the big, the bad and the ugly.

**1**

**2**

**3**

### 1 Create Some Thumbnails
This is just your run-of-the-mill group shot. By posing the villains in various sizes, you can create an effective composition that also conveys their collective personality—which is nothing short of evil. I block in the shapes very loosely, not worrying about any facial expressions yet.

### 2 Another Variation
This thumbnail is also a group shot, with the characters positioned a bit differently. I like the first one better because the composition here looks a little weak.

### 3 Action Shot
This sketch shows the villains in action. The reason I don't go with this one is that it looks too heroic.

### 4 Choose and Refine
Tighten your favorite thumbnail with a layer that is a bit darker. I add more detailed lines to show how the bodies will be positioned, and add hints for the final expressions.

### 5 The Not-So-Good Guys
Add ink and color, using strokes that vary in thickness to accent curves and lines. I chose to change the expressions a little from the previous sketch to add more variety. I liked it this way much better.

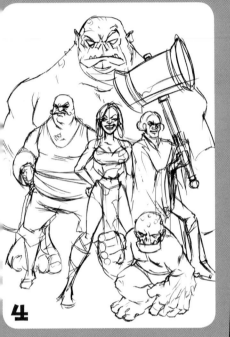

4

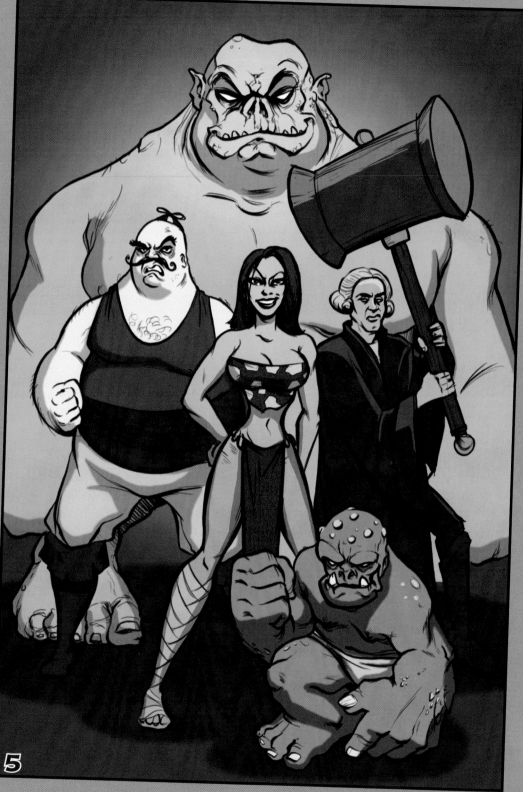

5

# BATTLE SCENE

**INTERIOR: Splash Page** Now, Brandon is going to mix it up a bit and show five characters in a life-or-death battle with each other. This will give us a great opportunity to explore all of the principles we've talked about in part three: closeups, long shots, composition, body language and line of action.

1

2

3

4

## 1 Create a Thumbnail
Here I've established three different planes of action: foreground (closeup), mid-ground (medium long shot) and background (long shot). Make sure there is a clearly defined line of action for each character.

## 2 Sketch and Adjust
Create a sketch on the scene based on your thumbnail. Make adjustments for placement, and add the details you want to focus on, such as the facial expressions of the foreground characters. This is a good time to rework and make subtle changes to your layout. If you're not drawing digitally, use a pencil with a soft lead and a good, soft eraser so you can keep making adjustments.

## 3 Refine Your Drawing
Tighten up the pencil work. Make any final adjustments to pose and detail in this step. Pay attention to the level of detail in the background characters; it should be lower than that of the foreground characters.

## 4 Clean Up and Ink
Clean up the drawing. Try to maintain the energy of the sketch in the final linework.

## 5 Battle Royale
Add color. Since this isn't a book on color theory, I'll just recommend that you have fun with it. If your eyes are bleeding, your color is probably too intense.

5

# Conclusion

Congratulations on making it this far! If you're anything like us, you flipped through the book and did only the demos that interested you. But if you're smart and went through the book step by step, then you really have a good idea of what it takes to bring your images to life using expression and body language. Now that you have finished the book, start over. Remember that this isn't the end: you must keep practicing. The more you draw and apply the principles outlined in this book, the better you will become as an artist and the more attractive you will become to the opposite sex. No, wait—I mean the more attractive your work will be to art buyers and prospective employers.

**A Very Impressed Art**          **Ben**
**Buyer and Future Employer**
Thank you for buying this book and adding to
our fledgling egos.

# Gallery

We've included a selection of our work for your viewing pleasure.

**Ben**

**Gibbs**

**Blake**

**Blake**

**Ben**

**Brandon**

170

Brandon

Gibbs

Brandon

**Gibbs**

**Brandon**

**Ben**

Brandon

Andre 3000

Blake

Gibbs

# Index

# If you're going to draw, draw with *IMPACT*!

This exciting and complete instructional package starts with the basics and progresses through step-by-step demos that take readers from line art to full, awe-inspiring color. Readers will get instruction on equipment, scanning, setting up pages, color theory, flatting, rendering, special effects, color holds, color separations, and even details on the business of becoming a professional colorist.

*ISBN: 978-1-58180-992-3*
*Paperback, 160 pages, #Z0939*

A pencil is all that's needed to bring a mecha world filled with heroic robots to life. *MechaForce* takes the reader on an exploration of the mecha comic style, revealing the secrets behind robotic anatomy and imaginative machinery. With more than thirty step-by-step demonstrations, including lessons on everything from perspective to basic drawing to refining and finishing final work, this book is a complete manual to drawing a wide array of robots and mechanical creations.

*ISBN: 978-1-60061-014-1*
*Paperback, 112 pages, #Z1061*

Drawing heroines and femme fatales has never been more fun. The second installment of the *Comic Artist's Photo Reference* series gives comic artists the same high-quality reference photos they found in *Comic Artist's Photo Reference: People and Poses*, this time focusing on women and girls of varying ages, ethnicities and body types. Readers will find 1000+ photos of attractive models to draw from along with four step-by-step lessons from professional comic artists using photos from the book. In addition to photos, the companion CD-ROM includes short videos and other bonus material.

*ISBN: 978-1-60061-003-5*
*Paperback, 144 pages, #Z0999*

**These and other fantastic Impact titles are available at your local bookstore or from online suppliers. Also visit our website at www.impact-books.com.**

# I Am Not
# a Short Adult!

*Getting Good at Being a Kid*

## Marilyn Burns
*illustrated by Martha Weston*

## Little, Brown and Company
**Boston**                    **Toronto**

This Brown Paper School book was edited and prepared for publication at The Yolla Bolly Press, Covelo, California, between November 1976 and May 1977. The series is under the supervision of James and Carolyn Robertson. Production staff members are: Jay Stewart, Gene Floyd, Sharon Miley, and Joyca Cunnan.

D

Published simultaneously in Canada
by Little, Brown & Company (Canada) Limited.
Printed in the United States of America. T 10/77

BB

Library of Congress Cataloging in Publication Data

Burns, Marilyn.
   I am not a short adult!

   (A brown paper school book)
   SUMMARY: Deals with various aspects of childhood including family, school, money, legal rights, TV and movies, body language, and generally, how to make the most of childhood right now.
   1. Children—Juvenile literature. 2. Children's rights—Juvenile literature. 3. Children—Law—United States—Juvenile literature. [1. Conduct of life] I. Title
HQ781.B89          301.43'14          77-24486
ISBN 0-316-11745-5
ISBN 0-316-11746-3 pbk.